Disciplines of African Philosophy

Ikechukwu Anthony KANU

authorHOUSE

AuthorHouse™ UK
1663 Liberty Drive
Bloomington, IN 47403 USA
www.authorhouse.co.uk
Phone: 0800.197.4150

© 2018 Ikechukwu Anthony KANU. All rights reserved.

No part of this book may be reproduced, stored in a retrieval system, or transmitted by any means without the written permission of the author.

Published by AuthorHouse 08/30/2018

ISBN: 978-1-5462-9742-0 (sc)
ISBN: 978-1-5462-9741-3 (e)

Print information available on the last page.

Any people depicted in stock imagery provided by Getty Images are models, and such images are being used for illustrative purposes only.
Certain stock imagery © Getty Images.

This book is printed on acid-free paper.

Because of the dynamic nature of the Internet, any web addresses or links contained in this book may have changed since publication and may no longer be valid. The views expressed in this work are solely those of the author and do not necessarily reflect the views of the publisher, and the publisher hereby disclaims any responsibility for them.

CONTENTS

Introduction .. vii

1. Towards An African Philosophy Of Religion 1
2. Towards An African Philosophical Anthropology ... 23
3. Towards An African Philosophy Of Development 34
4. Towards An African Bioethics 46
5. Towards An African Metaphysics 69
6. Towards An African Philosophy Of History 88
7. Towards An African Cosmology 111
8. Towards An African Philosophy Of Science 135
9. Towards An African Ethics 156
10. Towards An African Political Philosophy 169
11. Towards An African Philosophy Of Education 184
12. Towards An African Logic 198

INTRODUCTION

What distinguishes African philosophy from other philosophies is its 'africanity'. Every culture makes a contribution from its house of experience to the universal themes of philosophy, and this makes philosophy relevant to the reality of life. Each culture traces the unity of these themes, synthesizes and organizes them into a totality, based on each culture's concept of life, namely, the relationships between objects and persons and between persons and persons themselves. However, much this may sound repulsive this cultural contribution to philosophizing is what particularizes philosophy as European, Indian, Chinese or African. The 'africanness' of African philosophy speaks of the *sitz en leben* or *the Locale* within which the philosophy is done. This provides the ingredients that defines it as African, while the 'philosophiness' of African philosophy speaks of the rational human person involved in the process or enterprise of doing philosophy. This 'africanness' and 'philosophiness' speak of its particularity and universality which are basic ingredients in the philosophical process.

In this case, the culture of the African people and the person doing the philosophy are very important and indispensable

elements. When we speak of the culture of the African people, it means that African Philosophy must speak to African problems and situations. Secondly, the person doing the philosophy must either come from Africa, or an African living in Diaspora or someone not coming from Africa but living in Africa and involved in the life of the African people. Such a person can meaningfully and authentically contribute to the development of African thought.

For several decades, African philosophers have debated on the history, nature, methodology of African philosophy, among others; however, this piece takes a different turn. It reflects on the disciplines of African philosophy. It is a work of twelve chapters, and focuses on the major disciplines of African philosophy. This piece is a response to the recurrent question in the class of African philosophy: "What are the disciplines of African Philosophy?"

TOWARDS AN AFRICAN PHILOSOPHY OF RELIGION

1. Introduction

Religious themes have always emerged in the thoughts of Western and African philosophers. In the Ancient Era of Western philosophy, religious reflections abound in the writings of Pythagoras, who was greatly influenced by the Orphic religion, Plato, Aristotle and Epicurus. In the Medieval Season, it dominated the philosophical reflections of the philosophers of the Medieval world, as it is evident in the philosophies of Augustine, Pseudo-Dionysuis, Boethius, St Anselm, etc. Religious themes are also apparent in the treatises of many early modern philosophers, such as Locke, Berkeley, Hume, etc. This notwithstanding, in these treatises, there was only a mingling of religious themes with the broader concerns of philosophy, that is, in relation to the concerns of politics, logic, anthropology, epistemology, metaphysics, science, law etc.

A detailed study of the history of philosophy reveals that the dedication of philosophical texts wholly or exclusively to the study of religion is rather a recent thing. Thus, the term 'philosophy of religion' was first employed by Henry Moore in the 17th century with a specific focus on the philosophical study of religion. Since then, it has continued to develop as an area of study, and today, it is recognized as a branch of philosophy. An increased number of students are studying it in universities and seminaries, and scholarship is developing the discipline in new and previously unconsidered directions.

With the recent development in African studies, gradually opening up new vistas like African philosophy, African bioethics, African religion, African ethics, African logic, African science, African history, etc., this piece attempts to investigate the possibility of developing studies in African Philosophy of Religion. This could be considered a pioneer attempt in the direction of making a detailed and systematic study of an African Philosophy of Religion. However, before studying African philosophy of religion, it would be worthwhile to distinguish between African philosophy and African traditional religion, with the hope that it would pave the way for a clearer conception of African Philosophy of Religion.

2. African Philosophy

A cursory glance at the historical development of the discourses on the nature of African philosophy reveals four perspectives. Gbadegesin (1991) outlines these four perspectives as follows:

Disciplines of African Philosophy

a. The first group understands African Philosophy as the philosophical thought of Africans as could be sifted from their various world views, myths, proverbs, etc. In this sense, it is the philosophy indigenous to Africans, and untainted by foreign ideas. It is based on this understanding that Tempels (1959) wrote that "I confidently hope to be able to convince my readers that real philosophy can be found among indigenous peoples and that it should be sought among them" (p. 17).

b. The second group understands African philosophy as, the philosophical reflection on, and analysis of, African conceptual systems and social realities as undertaken by contemporary professional philosophers. This reduces African Philosophy to reflections by professionally trained philosophers who operate with the collaboration of traditional thinkers.

c. The third group understands African Philosophy as the combination of these two approaches, without suppressing or looking down on any. This would involve sifting philosophical thought of Africans as could be gotten from their various world views, myths, proverbs, etc, and reflecting on them by professionally trained African philosophers.

d. The fourth group argues that African Philosophy is not any of the above; however, its proponents represented by Hountondji (1976) regard African Philosophy as any collection of texts produced by Africans and specifically described by their authors as Philosophy.

While these views reveal the different groupings of perspectives on African philosophy over the years, none adequately, as an independent perspective, captures the meaning of African philosophy. From the first perspective, African philosophy, although includes, but not entirely domiciled in the myths, proverbs, folklores etc., of the African people. African philosophy has an extension capacity that encompasses contemporary events and issues. Holding on to that definition would make African philosophy to be a study of the past, but we know that African philosophy is contemporaneous. The second must be treated with reservation; this is because African philosophy goes beyond the thought of professional philosophers; there are also 'unprofessional' African philosophers. As regards the third, the comments for the first two definitions still apply. The fourth definition needs to be remodeled. Kanu (2015) argues that what makes a piece philosophical is not the author. What if a mad man was to be the author of an idea, and he calls his thought philosophy, does it make it philosophy? There should be principles that make a thought philosophical. Generally, African philosophy is a rational and critical enterprise that employs distinctive methods that are African in character in the interpretation of the African's experience of reality. The critical and rational nature of African philosophy distinguishes it from other areas of African study like African Traditional Religion and African Cultural Studies.

3. African Traditional Religion

African Traditional Religion, as a concept, can be employed in two complementary senses. Loosely speaking,

Disciplines of African Philosophy

it encompasses all African beliefs and practices that are considered religious but neither Christian nor Islamic. The expression is also used almost as a technical term for a particular reading of such beliefs and practices, one that purports to show that they constitute a systematic whole- a religion comparable to other world religions. The concept was introduced by G. Parrinder in 1954, but later developed by Bolaji Idowu and John Mbiti. However, Ekwunife (1990) defines African Traditional Religion as:

> Those institutionalized beliefs and practices of indigenous religion of Africa which are the result of traditional Africans' response to their believed revealing Superhuman Ultimate and which are rooted from time immemorial in the past African religious culture, beliefs and practices that were transmitted to the present votaries by successive African forebears. (p. 29).

He further writes that African Traditional Religion is a religion that is transmitted:

> Through oral traditions (myths, and folktales, songs and dances, liturgies, rituals, proverbs, pithy sayings, names and oaths), sacred specialists and persons, sacred space, objects and symbols, a religion which is slowly but constantly updated by each generation in the light of new experiences through the dialectical process of continuities and discontinuities. (p. 29).

Corroborating with Ekwunife, Awolalu (1979) writes:

> When we speak of African traditional religion we mean the indigenous religion of the Africans. It is the religion that has been handed down from generation to generation by the forebears of the present generation of Africans. It is not a fossil religion (a thing of the past) but a religion that Africans today have made theirs by living it and practising it. This is a religion that has no written literature yet it is "written" everywhere for those who care to see and read. (p. 26).

Awolalu further adds that:

> It is largely written in the people's myths and folktales, in their songs and dances, in their liturgies and shrines and in their proverbs and pithy sayings. It is a religion whose historical founder is neither known nor worshipped. It is a religion that has no zeal for membership drive, yet it offers persistent fascination for Africans, young or old. (p. 26).

African Traditional Religion is, therefore, a religion that has been with Africans for many generations, and with which they have lived their lives and solved their existential problems from time immemorial. Thus, Kanu (2015b) avers that it is a religion that is *co-terminus* with the African people and their society. The purpose of discussing African Traditional Religion as a theme in this study is to show the distinguishing line between African Traditional Religion and African philosophy and African philosophy of religion. These are three distinct concepts.

4. "African" as the Context for an African Philosophy of Religion

The presence of the concept "Africa" in the concept "African philosophy of religion" already speaks of or provides the *locus* or *locale* for doing the philosophy of religion called African. By Africa, Ki-zerbo (1981) refers to the land of sunshine, of black race and mostly refers to the sub-Saharan regions of the Negroes, encompassing the territory about the city of Cartage and the Sub-Saharan Africa. It is the second largest of the Earth's seven continents, covering 30,244,000 sq km (11,677,000 sq mi), including its adjacent islands with 54 countries. Robert (2003) observes that it encompasses 23 percent of the world's total land area. In 2000 some 13 percent of the world's population, an estimated 797 million people, lived in Africa, making it the world's second most populous continent, after Asia. Knappert and Pearson (1976), state that its peoples are divided into more than 1,000 ethnic groups, with different languages, social customs, religions and way of life. Izu (1997), articulated the geo-numerical identity of Africa thus:

> It covers an area of 11, 617, 000 square miles. It is three times the size of Europe (10, 400, 000 square kilometres and 4,000, 000 square miles) and contains about four hundred million inhabitants. Africa is divided into twenty five major ethnic groups speaking about seven hundred languages. It contains within it every known type of topography and climatic condition, except the Arctic cold. There are in the North the Sahara, and in the South

the Kalahari Desert, with permanent snow in the Kilmanjaro. Also found in Africa are jungle areas, temperate zones, swamps and Savannah. Finally, some of the highest falls and longest rivers in the world- the Nile, Niger, Zaire (now Congo), and Zambesi rivers- are also found in Africa. (p. 16).

African philosophy of religion, therefore, focuses basically on the religious experience of the African, and if there must be a reflection on religious experiences outside of the African, then it must be in relation to the African religious experience. Whatever reflection that falls outside of this parameter may not qualify to be considered an African philosophy of religion. Thus, African philosophy of religion must include a philosophical analysis of the African religious experience.

5. The Development of African Philosophy of Religion

There are a couple of literature on African Traditional Religion, which could have philosophical slants, however, cannot be referred to as philosophical texts, partly because the authors never set out to write a philosophical work. This notwithstanding, these texts have contained in them elements of African philosophy of religion. Such texts include: *Sacrifice in Igbo religion*, Arinze, F.; *West African traditional religion*, by Awolalu, J. O. & Dopamu, P. O.; *Igbo ritual symbols*, by Ejizu, C. I. O.; *Olodumare: God in Yoruba belief*, by Idowu, B.; *Fundamentals of religious studies*, by Madu, J. E.; *Comparative studies of African*

Traditional Religion, by Metuh, E. I.; *West African religion,* by Parinder, G. D.; *West African traditional religion,* by Quarcoopome, T. N., etc. The writers of these works did not set out to write a philosophical work *ab initio*. Thus, while their works can be referred to as containing some elements of African Philosophy of Religion, they cannot be regarded as African philosophy of religion texts. This is not to say that these works are irrelevant in the study of African philosophy of religion; they can be a starting point for African philosophers of religion as they provide the raw material or data for philosophical reflection.

The African universe being a deeply religious one, it has become increasingly difficult for many African philosophers to reflect on the African experience without delving into African religious themes like God, proofs of God's existence, life after death, divinities, ancestors etc. This notwithstanding, in the treatises of African philosophers, there was only a mingling of religious themes with the broader concerns of African philosophy, that is, in relation to the concerns of politics, epistemology, metaphysics, science, law etc. They did not originally set out to reflect on African philosophy of religion. Such works include: *Bantu philosophy,* by Tempels, P.; *An essay on African philosophical thought: The Akan conceptual scheme,* by Gyekye, K.; *Hermeneutics of God in Igbo ontology,* by Mbaegbu, C. C. A.; *Muntu: An outline of the new African culture,* Jahn, J.; *Essays in African philosophy, thought and theology,* by Njoku, F. O. C; *African philosophy: An ontologico-existential hermeneutics on classical and contemporary issues,* by Kanu, I. A. Although their works have chapters dedicated to philosophical reflections

on African philosophy of religion, they are not philosophical texts dedicated wholly or exclusively to the study of African philosophy of religion. The first attempt at dedicating a philosophical text to the study of African philosophy of religion can be traced to J. S. Mbiti's *African Traditional Religions and Philosophy*. On this point, African philosophers of the thorough going universalist school would distance themselves with this idea. However, the most recent attempt at dedicating a whole text to a philosophical study of African traditional religious thought is seen in Kanu, A. I.'s *A Hermeneutic Approach to the Study of African Traditional religion, Theology and Philosophy*. On the ability of such a text to represent a study of African philosophy of religion would also be controversial.

These notwithstanding, no matter how imperfect these developments represent a dedicated study in African philosophy of religion, they all constitute a part of the history of the development of what may be one day regarded as the history of African Philosophy of Religion. The idea of an African philosophy of religion is here employed to inspire further writings in this direction. It is also hoped that it would be a basis for further studies in African philosophy of religion.

6. Defining African Philosophy of Religion

African philosophy of religion is not to be understood as an enterprise that is out to defend African traditional religious convictions or experiences. It is not an organ of religious teaching, and as such, it is an enterprise open to all forms of

Disciplines of African Philosophy

religious traditions in Africa. It studies the concepts and belief systems of the African religions as well as the prior phenomena of religious experience and the activities of worship on which these belief systems rest and out of which they have arisen. African philosophy of religion would, therefore, analyze African conceptions of God, proof for the existence of God, religious symbols, salvation, worship, creation, divinities, ancestors, reincarnation, African religious language, myth, life after death, the problem of evil, morality and religion from a philosophical perspective, and with the philosophical method of analysis. Unlike other forms of study in the area of religion, African philosophy of religion is a neutral activity.

From the above, it can be said that African philosophy of religion is concerned with the justification of African religious beliefs with rational argumentation and the analysis of the central themes in African religious traditions. Thus, it focuses on determining the nature and status of African religious beliefs; its proximate aims, its motivations, their meaning and the truth that they command. And the primary aim why African philosophy of religion engages in this search is simply to determine the character and worth of African religions and religious experiences.

7. Selected Themes in African Philosophy of Religion

In the discussion of African philosophy of religion, there are various themes that build up this area of study. This includes God, evil and human suffering, divinities, immortality, etc. This section would focus on these themes:

a. God in African Ontology

God in the African universe, according to Quarcoopome (1987), from his names and attributes, is a reality and not an abstract concept. Idowu (1973) avers that he is a personal being with whom one can enter into communion and communication. He is approachable in all occasions of life. In societies where there is hierarchy of power, from the king to the chiefs and common people, the idea of God is also presented within the frame of a hierarchy. This is evident in the Yoruba, Benin and Akan concepts of God. However, where such hierarchies are not well developed, the idea of God is presented in plain terms, as among the Nupe and Tiv. Among some cultures, he is conceived as masculine, as among the Yoruba, Mende and Akan; in some others as feminine, as among the Ewe; in some others, he is conceived as both male and female, as among the Gas. The Yoruba call him *Olodumare* or *Edumare* (The King of heaven); The Igbo call him *Chukwu* or *Osebuluwa* (Great God or sustainer of the universe); The Edo call him *Osanobua* or *Osanobwa* (Creator and sustainer of the universe); The Nupe call him *Soko* (The supreme deity that resides in heaven); The Ijo call him *Temearau* (The creatress of all things –feminine term-); The Tiv call him *Aondo* (The power above that creates and rules all things); The Ibibio refer to him as *Obasi Ibom* (The God who lives above the earth); The Akan call him *Odomankoma* and *Nyame* (full of mercy and the God of fullness respectively); The Mende of Sierra Leone call him *Ngewo* (The eternal one who rules from above); The Kono of Sierra Leone call him *Meketa* (The Immortal or eternal); From these names of God from different African cultural backgrounds, his attributes already begin to emerge.

b. The Existence of God

The desperation to proof the existence of God is a Western phenomenon than African issue. This is because the African believes that God exists and does not need anyone to prove to him. God is part of his daily life. Edeh (1985), while speaking of the Igbo's relationship with God, writes:

> ... the Igbo is born in a religious atmosphere that makes the presence of God a living fact, he has not the least doubt that God exists. Consequently, the Igbo normally does not bother about a proof of God's existence. God is so near to man, so involved in man's existence, that one does not question Chukwu's existence. (p. 118).

Corroborating Edeh, Mbaegbu (2012) writes:

> It would be grossly baseless to suggest to an Igbo traditionalist that all his thoughts of the Supreme Being which are his own creations encapsulated in these names and attributes of Chukwu or God are false and misguided; worse still, if such natural creations are misappropriated to be the exclusive reserve property of the Christian missionaries. The earliest Igbo people possess the concept of the Supreme Being as a real existent being in their traditional ontology (p. 246).

While discussing the concreteness of God among the Yoruba people, Jahn (1961) writes that:

> God may be banished from Greek thought without any harm done to the logical architecture of it, but this cannot be done in the case of the Yoruba. In medieval thought, science could be dismissed at pleasure, but this is impossible in the case of Yoruba thought, since faith and reason are mutually dependent. In modern times, God even has no place in scientific thinking. This was impossible for the Yorubas since from the Olodumare an architectonic of knowledge was built in which the finger of God is manifest in the most rudimentary elements of nature. Philosophy, theology, politics, social theory, land law, medicine, psychology, birth and burial, all find themselves logically concatenated in a system so tight that to subtract one item from the whole is to paralyze the structure of the whole. (p. 97).

These perspectives register the understanding that the African does not depend on proofs like the westerner in order to believe in the existence of God. The first attempt at providing Igbo-African proofs of the existence of God was done by Edeh (1985). This he was able to build from the responses he got from the questionnaire he gave Mr Ede Ani Onovo, a native of Nkanu and a man well known for his wisdom and knowledge. He refers to his proofs as five ways of coming to know about *Chukwu*, which include: the existence of things in nature, Igbo nomenclature, the Igbo concept of *Chi* and the Igbo idea of life and death. Mbaegbu (2012), building on Edeh's, went further to develop the proofs of the existence of God in Igbo ontology. However, contrary to Edeh, he was motivated to develop these proofs to

prove to missionaries that there was the idea of the Supreme Being in Igbo traditional ontology, and that the idea of Supreme Being was not influenced by missionary activities among the Igbo. While Edeh refers to his proofs as possible ways of arriving at the existence of God, in Mbaegbu the concept for describing the proofs attains systematization, he referred to them as: traditional rational proofs for the existence of God.

c. The Problem of Evil and Human Suffering

From the Igbo perspective, suffering is expressed in the Igbo word *ahuhu,* which means an unfavourable situation which ought not to be. The word can be applied in a strict sense and in a broad sense. In a strict sense, *ahuhu* connotes a gravely difficult, painful and dishonourable situation which a person undergoes as punishment for offences committed against the deities, humanity or the created order. This definition agrees with the Igbo unified view of reality, which sees the world as having an ontological link. Thus, Madu (2004) maintains that "There is an ontological link of the different spheres of the cosmic order, to the extent that what affects one sphere invariably will affect the other" (p. 21). From the Igbo perspective, suffering is retributive and proportionate to the abomination committed. The Igbo would therefore say *Isi kote ebu ogbaa ya* (the head that pushes the wasp hive receives the sting) and *mpuru onye kuru, ka oga'ghoru* (whatever a man sows that he would reap). According to Ezeanya (1994) "Suffering of every kind – epidemic, sickness of all sorts, accidents, fire outbreak, natural disasters like flood, and earthquakes were

all attributed to the influence of the powers above man, both good and evil showing their displeasure at human offence" (p. 19). Suffering is believed to be perpetrated by bad spirits *ndi ajo nmuo* and sometimes the ancestors could also inflict suffering. There were also human collaborators known as *ndi ajo nmadu*. They collaborate with bad spirits, witches and sorcerers to inflict suffering on fellow human beings.

In a loose sense, the Igbo understand suffering as any kind of painful or difficult experience resulting from situations or painstaking efforts to achieve difficult objectives. It is in this regard that suffering is understood in terms of *opipia,* that is, penance, usually done to achieve spiritual growth, or *olu ike or olu siri ike,* that is, hard work, as in the case of a man who works at a cement industry, daily carrying about 500 bags of cement from one point to another, it is considered *ahuhu,* but for the purpose of raising money to take care of his family. In this case it also refers to *igba mbo* (making serious effort). This kind of suffering brings hope and does not lead to despair or destruction. The Igbo would say: *mmiri mmadu kwosara onwe ya adighi atu ya oyi* (the water a person pours upon himself does not bring him or her cold). Hard work is at the centre of the Igbo spirit. The Igbo would say: *onye obula choro ihe mara mma ga adi nkwadobe ikuchara ya okpofufu n'ihi na o dighi ije oma na-ada ne'lu* (one who desires great things must be ready to work hard), in another proverb, the Igbo would say: *o bu naani ukwu gbara apiti na eri ihe guru ya* (It is only the leg that is soiled with mud that enjoys whatever it likes). This kind of suffering is not a curse but attracts blessings from God. Greatness is achieved through hard work. There are generally, three approaches

to the problem of evil and human suffering. The first is the Igbo cosmological optimistic view which traces evil and human suffering to human beings. There is the human destiny view which interprets evil and human suffering as part of the destiny of a person. There is also the eclectic view which combines the two perspectives above.

d. Morality and Religion

In Africa, there is widespread belief in a Supreme God, with a profound sense of the sacred and mystery. Thus, it is difficult to separate the life of the African from his personal inclinations to the divine. It is in this regard that he does everything with the consciousness of God. Mbiti (1969) puts this succinctly:

> Wherever the African is, there is his religion. He carries it to the fields where he is sowing seeds or harvesting new crop, he takes it with him to a beer parlour or to attend a funeral ceremony; and if he is educated, he takes religion with him to the examination room at school or in the university; if he is a politician, he takes it to the house of parliament. (p. 2)

Relating the dominance of religious perspectives in African life, Opoku (1974) avers that "It may be said without fear of exaggeration that life in the Akan world is religion and religion is life". (p. 286). Opoku (1978) connecting the interpenetration of religion to morality wrote that "Generally, morality originates from religious considerations, and so pervasive is religion in African culture that ethics

and religion cannot be separated from each other" (p. 152). Sarpong (1972) stated that "Ethics here emerges with religion and religious practices" (p. 41). Busia (1967) also wrote that "Religion defined moral duties for the members of the group or the tribe" (p. 16). Agreeing with these perspectives, Danguah (1944) avers that "Everything has value only in relation to the idea of the great ancestor" (p. 3).

Gyekye (1987) rejected the link established by these scholars between religion and morality as mistaken. He observed that these scholars speak of morality only in terms of moral rules or norms, while forgetting that morality involves the conduct of people or the pattern of behaviour. It is therefore not clear if these perspectives are of the view that morality is bound up with religion or if it is that religious beliefs influence human actions, or if both is meant. The reason of Gyekye distancing religion from morality was based on his research among the Akan people of Ghana in which he discovered that the concepts of good and evil are used not because the divine has sanctioned them, but because it helps humanity. He thus, prefers to talk of a humanistic or non-supernaturalistic origin of morality rather than a religious origin of morality which emphasizes the wellbeing or welfare of the community. Wirendu (1983), Summer (1983) and Oluwole (1990), while arguing for the Akan, Ethiopian and Yoruba ethics respectively, had written in the same terms when they argued that African morality is founded on rational reflection, that is, as to what is conducive to human welfare. Omoregbe (2005) and Wirendu (1983 and 1995) have also argued along the same line.

It is true that morality is not religion, but to argue that morality has no relationship with religion sounds plausible but not real. It was not so much about that God has given the moral law, but that these laws when broken offends him and the ancestors who upheld them. God is part of the ontological order, and to do anything that harms the human person is to distort the ontological order and thus would attract divine wrath. In African traditional societies there was the fear of the ancestors and divinities. The idea of the relation of morality to the divine gave morality a strong value in African traditional societies and further affected behaviour, that is, the response of men and women to that law. African ethics therefore, has both a religious and humanistic basis. It is religious and humanistic at the same time because in African ontology, the human person occupies the central place.

8. Conclusion

The African religious themes that could be subjected to a philosophical reflection goes beyond the ideas of God, the existence of God, evil and human suffering, morality and religion. There are several other themes that could be discussed in the study of African philosophy of religion. These themes include ancestors, divinities, reincarnation, witchcraft, etc. What makes the difference between African philosophy of religion and other African religious and cultural studies is the method employed by African philosophy of religion, the methodology of rational argumentation and analysis of African religious themes and experiences. While this study serves as a pioneer attempt in

the systematic study of African Philosophy of Religion, it targets at inspiring a more intense and systematic analysis in the area of African Philosophy of Religion. Thus, the term 'African philosophy of religion' is adopted with a specific focus on the philosophical study of religion. It is hoped that it would develop as an area of study, and one day be recognized as a branch of African philosophy. It is also hoped that an increased number of students would study it in universities and seminaries, especially as scholarship is developing in new and previously unconsidered directions.

References

Awolalu, J. O. (1979). Yoruba belief and sacrificial rites. Ikeja: Longman.

Busia, K. A. (1967). *Africa in search of democracy*. New York: Praeger.

Danguah, J. B. (1944). *The doctrine of God: A fraction of Gold Coast ethics*. London: Lutterworth.

Ekwunife, A. N. O. (1990) *Consecration in Igbo Traditional Religion*. Onitsha Publishers Ltd.

Ezeanya, S. N. (1989). *The Christian and suffering*. Onitsha: Tabansi.

Gbadegesin, S. (1991). *African philosophy: Traditional Yoruba philosophy and contemporary African realities*. New York: Peter Lang Press.

Gyekye, K. (1987). *An essay on African philosophical thought: The Akan conceptual scheme*. Cambridge: Cambridge University Press.

Hountondji, P. (1995). *African philosophy: Myth and reality*. Paris: Francois Maspero.

Idowu, B. (1973). *Olodumare: God in Yoruba belief.* London: Longman.

Izu, O. M. (1997). *Africa: The question of identity.* Washington: The Council for research in Values and Philosophy.

Kanu, I. A. (2015). *A hermeneutic approach to African Traditional Religion, theology and Philosophy.* Nigeria: Augustinian.

Kanu, I. A. (2015). *African Philosophy: An ontologico-existential hermeneutic approach to classical and contemporary issues.* Nigeria: Augustinian.

Ki-Zerbo (1981). *General history of Africa.* London: Heinemann.

Knappert, J. & Pearson, J. (1976). *The Spectrum Encyclopedia of Africa.* Ibadan: Spectrum.

Madu, J. E. (2004). Honest to African cultural heritage. Onitsha: Coskan.

Oluwole, S. B. (1990). The rational basis of Yoruba ethical thinking. *The Nigerian Journal of Philosophy.* 4. 15-25.

Omoregbe, J. (2005). Ethics in traditional African society. In P. Iroegbu and A. Echekwube (Eds.). *Kpim of morality:Ethics, general, special and professional* (pp. 36-42). Nigeria: Heinemann.

Opoku, K. A. (1974). Aspects of Akan worship. In C. E. Lincoln (Ed.). *The black experience in religion* (pp. 280-296).

Opoku, K. A. (1978). *West African traditional religion.* Singapore: SEP International Private.

Quarcoopome, T. N. (1987). *West African traditional religion.* Ibadan: African Universities Press.

Sarpong, P. A. (1972). Aspects of Akan ethics. *Ghana Bulletin of Theology.* 4. 3. 40-54.

Tempels, P. (1959). *Bantu philsoophy.* Paris: Presence Africaine.

Wirendu, K. (1983). Custom and morality: A comparative analysis of some African and Western conceptions of morality. *Conceptual decolonization in African philosophy* (pp. 33-52). Ibadan: Straum Limited.

Wirendu, K. (1995). Morality and religion in Akan thought. In H. O. Odera and D. A. Wasola (Eds.). *Philosophy and culture* (pp. 6-11). Kenya: Bookwise.

TOWARDS AN AFRICAN PHILOSOPHICAL ANTHROPOLOGY

1. Introduction

Anthropology only began to emerge as an independent and systematic field of study in the middle of the 19th century. This emergence is linked to Charles Darwin's theory of evolution by natural selection- it drew great attention to the study of the human person as it became widely accepted among many scientists. By the 20th century, as different persons began to delve into the study of anthropology, different areas of anthropology also began to emerge. As philosophers began to study anthropology, the idea of a philosophical study of anthropology under the name-philosophical anthropology emerged as well.

Audi (1999) defines philosophical anthropology as "a philosophical enquiry concerning human nature, often starting with the question of what generally characterizes human beings, in contrast to other kinds of creatures and things" (p. 667). More simply, Mundi (1998) defines it as

the philosophical study of man. Bergamino (2007) refers to this discipline as a "philosophical research that seeks to gather the essence of man, that is, the precise modality of being that confers the essence of 'manness' to any human subject and permits him to be such in more varied changes that besiege his existence" (pp. 13-14). This study would involve integrating the findings of scientific researches on the human person, and thus the need for openness to the findings of science, such as biology.

The study of what consists of the human person from the western perspective reveals the emergence of two schools: the vitalists and the mechanists (Mondin, 1998). The general tendency of vitalists is to consider life as a singular original phenomenon, irreducible to matter. They posit that in the living organism are found phenomenon of self-construction, self-conservation, self-regulation and self-repair, which are not found in machines. The representatives of this school are basically of the Judeo-Christian Tradition (Ebeh, 2010).

However, with the triumph of mathematics and science, philosopher-scientists began to give a mechanistic interpretation to life. They observed that the human body is a well contrived machine, with its levers (bones), its pumps (heart), its bellows (lungs), etc. Descartes and Leibniz proposed the analogy of living organisms and machines, in particular the clock. From this perspective, the human person is understood as a singular organization of matter. With the dawn of modernism, animated by the Cartesian anthropological philosophy, which overthrew the theocentricism of the medieval world, practical philosophies began to feature prominently on the

landscape of philosophy, giving greater impetus to science and technology: 'the conquest of nature'. This has further promoted the mechanistic concept of the human person, thus, giving less value to the vitalist position.

With this development in Western philosophical anthropology, the circumstance has arisen which questions the position of African philosophy on who the human person is. This has become even more important in our own generation of globalization when there is a growing need to be in communication with regional characterization in virtually every field of human endeavour. The drive of this piece is, therefore, to philosophically investigate the concept of the human person from an African perspective. Before such an investigation, it would be worthwhile to first study and establish the meaning of African Philosophical Anthropology.

3. Defining African Philosophical Anthropology

African philosophical anthropology can be understood as a discipline that deals with the questions of the metaphysics and phenomenology of the human person, and interpersonal relationships from an African perspective. The idea of the concept "Africa" in African philosophical anthropology speaks of or provides the *locus* or *locale* for doing the philosophical anthropology called African. Thus, for it to be an African philosophical anthropology, the human person must be studied from an African perspective. By Africa, Ki-zerbo (1981) refers to the land of sunshine, of black race and mostly refers to the sub-Saharan regions

of the Negroes, encompassing the territory about the city of Cartage and the Sub-Saharan Africa. It is the second largest of the Earth's seven continents, covering 30,244,000 sq km (11,677,000 sq mi), including its adjacent islands with 54 countries. It encompasses 23 percent of the world's total land area. In 2000 some 13 percent of the world's population, an estimated 797 million people, lived in Africa, making it the world's second most populous continent, after Asia. Knappert and Pearson (1976), state that its peoples are divided into more than 1,000 ethnic groups, with different languages, social customs, religions and way of life. Izu (1997), articulated the geo-numerical identity of Africa thus:

> It covers an area of 11, 617, 000 square miles. It is three times the size of Europe (10, 400, 000 square kilometres and 4,000, 000 square miles) and contains about four hundred million inhabitants. Africa is divided into twenty five major ethnic groups speaking about seven hundred languages. It contains within it every known type of topography and climatic condition, except the Arctic cold. There are in the North the Sahara, and in the South the Kalahari Desert, with permanent snow in the Kilmanjaro. Also found in Africa are jungle areas, temperate zones, swamps and Savannah. Finally, some of the highest falls and longest rivers in the world- the Nile, Niger, Zaire (now Congo), and Zambesi rivers- are also found in Africa. (p. 16).

African philosophical anthropology, therefore, focuses basically on the philosophical analysis of the African

understanding of the human person. Whatever reflection that falls outside of this may not be considered an African philosophical anthropology.

3. The Humanistic Character of the African Universe

African cosmology is heavily anthropocentric. Man is at the centre of the universe, more central than God. According to Mbiti (1969), "Man is at the very centre of existence and African people see everything else in its relation to this central position of man… it is as if God exists for the sake of man" (p. 92). Corroborating with Mbiti, Metuh (1991), avers that "Everything else in African worldview seems to get its bearing and significance from the position, meaning and end of man" (p. 109). The idea of God, divinities, ancestors, rituals, sacrifices etc., are only useful to the extent that they serve the needs of man.

The African universe has physical and the spiritual dimensions (Edeh 1983, Abanuka, 1994, Ijiomah 2005, Unah 2009). At the spirit realm, God represents the Chief Being, and sits at the apex of power. In the physical world, human beings dominates, occupying the central position in the scheme of God's creation. Onunwa (1994) believes that the African cosmos is like an isosceles triangle, God (the Supreme Being) is at the apex. The ancestors are at the base of the triangle, while at the centre are human beings. The primacy of the human being in the African universe is due to the central place the human person occupies within the universe. The triangular imagery suggests that human beings

form a "microcosm" on which converge the innumerable forces and influences from the beings that inhabit the other arms of the universe.

4. Man as a Theocratic Being

The analysis of the Yoruba idea of a human person as *eniyan*, reveals the African concept of man as a being having its origin and finality in the Supreme Being. This implies that man in the African universe is best understood in his relationship with God his creator, to whom, from the Igbo perspective, he is ontologically linked with through his *chi*, the spark or emanation of God in each person. His or her life is understood as a gift from God. Thus, the Igbo bear the names:

 a. *Chi-nyere ndu:* God gave life
 b. *Nke-chi-yere:* the one God has given
 c. *Chi-n'eye ndu:* God gives life
 d. *Chi-di-ogo:* God is generous
 e. *Chi-nwe- ndu:* God owns life
 f. *Chi-ji-ndu:* God owns life

Man's existence is not the product of chance. According to Kanu (2015a), in African worldview the human person has a purpose and mission to fulfill; he comes into the world as a force amidst forces and interacting with forces. Good status, good health and prosperity are signs of the wellbeing of a person's life-force, and man struggles to preserve it through an appropriate relationship with the spiritual forces around him. The goal of every human person is to achieve his *akara chi*, the destiny imprinted on his palm by his *chi*.

Although the human person comes from God, his birth is not a separation from God. He still relates with the divine in a community of ways: Through ***libation***: which are prayers usually said in the morning time or during ceremonies, meetings and gatherings using *oji* (kola nut) and *mmanya-oku* (hot drink), the food and drink of the gods. Ijiomah (2005) avers that in prayer, "the Igbo man tries to normalize the relationship among the three worlds ... libation is made to God through the agency of the ancestors and other deities" (p. 87). **Through divination**: which involves a process of inquiry. People who wish to know why certain things happen, how to solve certain problems and so on, go to diviners.

5. The Human Person as a Being with the Other

Kanu (2015b) avers that the human person is not just an individual person, but one born into a community whose survival and purpose is linked with that of others. Thus the human person is first a member of a clan, a kindred or a community. Thus, the African believes that "when a man descends from heaven, he descends into a community". The community rejoices and welcomes his arrival. As the child grows, he becomes aware of his dependence on his kin group and community. According to Mulago (1989):

> The community is the necessary and sufficient condition for the life of the individual person. The individual person is immersed into the natural world and nevertheless emerges from it as an individual and

a person within his conscience and freedom given him by the mediation of the community in which he senses a certain presence of the divine. (p. 115).

Mbiti (1969) has classically proverbialized the community determining role of the individual life, "I am because we are and since we are, therefore I am" (p. 108). The community, according to Pantaleon, gives the individual his existence. That existence is not only meaningful, but also possible only in a community (Kanu, 2012b). To be is to belong and to belong is to be.

6. The Three Dimensions of the Human Person

According to Oduwole (2010), Yoruba scholars agree that the human person is made up of three basic elements: *Ara* (body), *Emi* (breath) and *Ori* (soul). This is also true of the constituents of man in Igbo ontology: *Obi* heart or breath, *Chi* destiny, *Eke* or *Agu* ancestral guardian. Idowu (1962) describes the body as the concrete, tangible thing of flesh and bones which can be known through the senses. As regards the *Emi*, he describes it as spirit, and this is invisible. It is that which gives life to the whole body and thus could be described through its causal functions: Its presence in the body of a person determines if the person still lives or is dead. According to Oduwole (2010), the body is the creation of *Orisha nla* (Arch-divinity). He was assigned by *Olodumare* (the Supreme Being) to mould the body of human beings. It is only the Supreme Being that puts the spirit into the body so as to give it life. Yoruba philosophy on the human person

does not end with the body and spirit, there is a third element called the soul. The soul affirms that the human person already has individuality in the spiritual world before birth. From this understanding, life does not begin with birth, it begins as soon as one acquires the soul which defines a person's individuality. The soul of the human person begins to live even before there is a body for its abode.

7. Conclusion

African anthropology initially controlled the production of anthropological knowledge and the result was functionlist studies - it was aimed at enhancing colonialism. It was not surprising that these studies were explicitly often myopic. After the colonial period, the new nations of Africa dismissed anthropology both as a cultivation of primitivism and as an apologetic for colonialism. This notwithstanding, circumstances have arisen for the social sciences, including anthropology, across Africa to regroup and to face the challenges that confront us as a continent and as part of the human family. It will be salutary for Africans to bring their own particular perspectives to all the social sciences, including anthropology.

References

Abanuka, A. (1994). *A new essay on African philosophy.* Nigeria: Spiritan.
Audi, R. (1999). *Philosophical anthropology.* Cambridge Dictionary of Philosophy (667-668). Cambridge: Cambridge University Press.

Bergamino, F. (2007). *La struttura dell'Essere Umano: Elementi dell'Anthropology Filosofica*. Roma: Edusc.

Ebeh, J. (2010). *African concept of life, person and community: contribution to global bio-ethical discourse*. In person and personhood: A philosophical Study. Enugu: SNAAP.

Edeh, E. (1983). *Towards Igbo metaphysics*. Chicago: Loyola University Press.

Ijiomah, C. (2005). African philosophy's contribution to the dialogue on reality issues. *Sankofa: Journal of the Humanities. 3. 1.* 81 – 90.

Izu, O. M. (1997). *Africa: The question of identity*. Washington: The Council for research in Values and Philosophy.

Kanu, I. A. (2012). The concept of life in Igbo-African anthropology. In Ezenweke, E. O. and I. A. Kanu (Eds.). *Issues in African traditional religion and philosophy (pp. 61-72)*. Jos: Augustinian.

Kanu, I. A. (2015). *A hermeneutic approach to African Traditional Religion, theology and Philosophy*. Nigeria: Augustinian.

Kanu, I. A. (2015). *African Philosophy: An ontologico-existential hermeneutic approach to classical and contemporary issues*. Nigeria: Augustinian.

Ki-Zerbo (1981). *General history of Africa*. London: Heinemann.

Knappert, J. & Pearson, J. (1976). *The Spectrum Encyclopedia of Africa*. Ibadan: Spectrum.

Mbiti, J. S. (1969). *African religions and philosophy*. Nairobi: East African Educational Publishers.

Metuh, I. E. (1991). *African religions in western conceptual schemes*. Jos: Imico

Mulago, V. (1989). *African heritage and contemporary Christianity*. Nairobi: Oxford University.

Mundi, B. (1998). *Philosophical anthropology*. India: Theological Publications India.

Onunwa, U. (1994). The individual and community in African Traditional Religion and society. *The Mankind Quarterly. 34. 3.* 249 – 260.

Unah, J. (2009). Ontologico – epistemological background to authentic African socio-economic and political institutions. A F. Uduigwomen (Ed.). *From footmarks to landmarks on African philosophy* (264 – 278). Lagos: O. O. P.

TOWARDS AN AFRICAN PHILOSOPHY OF DEVELOPMENT

Introduction

The question of the meaning of development has become a burgeoning interrogation in Africa, and responses to the question have attracted a retinue of perspectives from different backgrounds. A cursory glance at the different perspectives on this issue reveals that they are rather reductionist perspectives rather than wholistic in nature. These perspectives are regarded as reductionist in the sense that they hold a perspectival perspective of reality as evident in the philosophies of the empiricists and rationalists who hold onto a piece of reality as though it were the essence of reality. One of the models of a reductionist concept of development is the science and technology model. This, according to Bhagavan (1990), is based on the created impression and conviction that sees science and technology as the key that unlocks the door of development; thus, more scientifically and technologically advanced societies are understood as more developed than the others. It is on

this basis that some countries in the world are regarded as developed, others as developing and some others as underdeveloped. This notwithstanding, Oraegbunam (2009) avers that the human person is more than science and technology, and, thus, to lock up development within the compartment of science and technology is only to limit development. Heidegger (1977) in this regard avers that science and technology is only a means to an end and not an end in itself.

Economism has also associated development with economic growth. This perspective is evident in Karl Marx who argued that the economy of a nation is the substructure upon which other structures rest. As such, once there is a positive change in the Gross National Product of a nation, it is said to be developed, and when it is contrary, the country is said to be underdeveloped. The association of economic growth with development has led to what Kim (1981) refers to as a cult of money and the dehumanization of the human person. It was this inordinate and reckless drive for development that led to the slave trade and colonialism. In the name of boosting economic growth humanity was degraded and divided. Development cannot be associated with a system that dehumanizes and divides human beings. Development must begin with people and not destroy people; thus, it must go beyond economic growth.

There is also the secularist and historicist model of development which is associated with the dawn of modernism, animated by the Cartesian anthropological philosophy, which overthrew the theocentricism of the

medieval world, giving birth to practical philosophies that undermined religious and supernatural authorities. This perspective is the basis for enlightenment, agnosticism and atheism. Its proponents strongly believe that development is predicated on autonomy rather than hegemony. This perspective features prominently in the philosophies of Hume, Nietzsche, Darwin, etc. the end result of this position is the reduction of man to a chain of evolutionary processes that are devoid of meaning. The human person becomes a kind of machine, a clock, commoditized and depersonalized in the image of a big vending machine; this diminishes his value as a human person. It, therefore, becomes very difficult to associate development with such a perspective.

In the face of these perspectives on development, the question that looms at the horizon of this work is, from the African perspective, what is development? What contribution can African anthropology and metaphysics make to the pool of literature on development? Since development is used in relation to the human person, the question that needs to be attended to first, is 'who is man in African ontology?' An understanding of the human person would help shape an African integral and humanistic concept of development.

Man as a Substructure for an African Philosophy of Development

Different perspectives about the human person have merged over the years, and these perspectives have equally affected the concept of development. Kierkegaard speaks of the 'anguished man', Karl Marx of the 'economic man', Sigmund

Freud of the 'erotic man', Nietzsche of the 'man as the will to power', Heidegger of the 'existent man', Cassirer of the 'symbolic man', Bloch of the 'utopic man', Marcel of the 'problematic man', Gehlen of the 'cultural man', Mounier and Scheler of man as the 'incarnate spirit', Ricoeur of the 'fallible man'. In the midst of these Western perspectives of the human person, how does the African see the human person? And how does this shape the African concept of development?

The African world is heavily anthropocentric. Man is at the centre of the universe, more central than God. Thus, Mbiti (1969) avers that "Man is at the very centre of existence and African people see everything else in its relation to this central position of man… it is as if God exists for the sake of man" (p. 92). Corroborating with Mbiti, Metuh (1991), avers that "Everything else in African worldview seems to get its bearing and significance from the position, meaning and end of man" (p. 109). The idea of God, divinities, ancestors, rituals, sacrifices etc., are only useful to the extent that they serve the needs of man.

The African universe has physical and the spiritual dimensions (Edeh 1983, Abanuka, 1994, Ijiomah 2005, Unah 2009). At the spirit realm, God represents the Chief Being, and sits at the apex of power. In the physical world, human beings dominates, occupying the central position in the scheme of God's creation. Onunwa (1994) believes that the African cosmos is like an isosceles triangle, God (the Supreme Being) is at the apex. The ancestors are at the base of the triangle, while at the centre are human beings. The

primacy of the human being in the African universe is due to the central place the human person occupies within the universe. The triangular imagery suggests that human beings form a "microcosm" on which converge the innumerable forces and influences from the beings that inhabit the other arms of the universe. With this understanding of the human person, man is not defined according to his colour, nation, religion, creed, political leanings, material contribution or any matter. The human person has a dignity that must be preserved from every form of exploitation. He is a being with the other, and, thus, should have a wholistic approach to development. Although a human being, he is made up of various forms and aspects.

Development and the African Culture

The encounter between Western and African cultures was one that looked down on the African culture as underdeveloped, and thus the need to be discarded. In this encounter, many Africans forsook their culture in pursuit of the Western culture often associated with development. The African culture was described in derogatory terms as pagan, fetish, idolatry, etc. This raises a question as regards the relationship between culture and development. In relating development with the African culture, Wirendu (1998) avers that:

> Nevertheless, it is a fact that Africa lags behind the west in the cultivation of rational inquiry. One illuminating (because fundamental) was of approaching the concept of 'development' is to measure it by the degree to which rational methods

> have penetrated thought habits. In this sense, of course, one cannot compare the development of peoples in absolute terms. The western world is 'developed,' but only an aspect, and that is not the core, of development. The conquest of the religious, moral and political spheres by the spirit of rational inquiry remains, . . . a thing of the future even in the west. From this point of view the west may be said to be still underdeveloped. The quest for development, then, should be viewed as a continuing world-historical process in which all peoples, western and non-western alike, are engaged. (p. 195).

If African development efforts would be considered successful, it is not in the discarding of her culture but in the preservation and safeguarding of her heritage. This does not in any way imply that preservation excludes openness to external influences. If they add value to the African cultural heritage, Africa should be open to them. To be open to other cultures without a prior establishment of self-identity would usher in the loss of identity and authenticity. With the African history, inundated by varying proportions of assimilation, true development must begin with mental decolonization for the restoration of the African humanness.

A Complementary Notion of Development

The human person and the nature of reality in African ontology is generally complementary. Kanu (2015a&b) and (2016a&b) in the complementary philosophy of *Igwebuike*,

understands reality as being composed of beings that are in relation to the other. Asouzu (2007b), the Father of African complementary philosophy, in his philosophy of *Ibuanyidanda*, presents the African reality as "an all-embracing whole, in which all units form together a dynamic play of forces, which are in harmony with each other, by completing and supporting the other" (p. 14). Asouzu (2004) further speaks of reality as "necessary complements of each other" (46). While describing the human society, Asouzu (2007a) advanced that, "Human beings and societies exist only in relations" (p. 74). Taking from the above ontology, the African concept of development is all-embracing. This is contrary to the impression one gets from the different perspectives on development which makes it seem like a relative concept. The African does not in the name of development exploit the other. He does not in the name of development destroy his environment. He does not in the name of development make a caricature of the supernatural beings that constitute a fundamental part of the universe. He sees himself as part of a whole, a whole which all these constitute complementary elements for the well being of all.

It is from this African perspective that Wirendu (1998) insists that the human perspective on development must be wider than the myopic perspectives on development. He writes:

> Man should link the modernization of the conditions of his life with the modernization of all aspects of his thinking. It is just the failure to do this that is responsible for the more unlovable features of life

in the West. Moreover, the same failure bedevils attempts at development in Africa. Rulers and leaders of opinion in Africa have tended to think of development in terms of the visible aspects of modernization – in terms of large buildings and complex machines, to the relative neglect of the more intellectual foundations of modernity. It is true that African nations spend every year huge sums of money on institutional education. But it has not been appreciated that education ought to lead to the cultivation of a rational outlook on the world on the part of the educated and, through them, in the traditional fold at large. Thus it is that even while calling for modernization, influential Africans can still be seen to encourage superstitious practices such the pouring of libation to spirits in the belief that in this kind of way they can achieve development without losing their Africanness. The second advantage of seeing development in this way suggested above is that the futility of any such approach becomes evident. To develop in any serious sense, we in Africa must break with our old uncritical habits of thought; that is we must advance past the stage of traditional thinking. (pp. 195-196).

In the past, discussions and commentaries on development easily tended to be developed by economists, scientists, etc., who saw it primarily from the perspective of economic and scientific growth. While economic growth or scientific advancement is a positive sign, for the African, it does not constitute the full picture of development. Thus, as

Nwajiuba (1999) observes, it is possible that there could be an economic growth, scientific advancement but not development. Development observes Onwuliri (2008) goes beyond the narrow lines of economic and material advancement. It is all encompassing.

Conclusion

With the African understanding of the human person, the African concept of development is one in which man is at the centre of development itself. His interest and wellbeing, in line with the interests and wellbeing of others must be captured in every true development. As Ndiaye (1987), man is the driving force of development and at the same time, the beneficiary of development. Man is the *terminus ad quo* from which every development project moves and around which every development project must be polarized. Being a being Scheler (1970) describes as a 'so vast, so varied, so multiform, that every definition demonstrates itself as too limited', an understanding of development in relation to man must, therefore, include all the above dimensions: economic, social, religious, etc. as Oraegbunam (2009) writes of man: "He is a *homo scientificus*, a *homo technologicus*, a *homo economicus*, a *homo sapiens*, a *homo religiousus*, a *homo rationalis*, a *homo moralist, homo politicus, home faber, homo transcendentalis, homo spiritualis, homo eschatologicus* all together" (p. 71). The concept of development must therefore not be related to only one or two of the above. Development should thus be wholistic, complementary. In relations to the African culture, no culture is superior to the other. And if no culture is superior to the other, then none should be considered a

symbol of development and the other, underdevelopment. Africans need not look down on their own cultural heritage in the pursuit of western ways of life. The understanding of development in the sense of solely modernization is restrictive and myopic. Development against the backdrop of modernization, according to Wirendu (1998), should be seen as "one in which Africans in common with other peoples seek to attain a specifically human destiny"(p. 190).

References

Ndiaye, M. (1985). Conception of man and development: A Muslim viewpoint. In H. Dobers, W. Erl, A. Khoury, A. Ndam-Njoya (Eds.). *Development and solidarity: Joint responsibility of Muslims and Christians* (pp. 30-42). Mainz: Haze & Koehler Verlag.

Heidegger, M. (1977). *The question concerning technology.* New York: Harper and Row.

Oraegbunam, I. K. E. (2009). *Journal of the Nigerian Philosophical Association.* 5. 6. pp. 56-81.

Bhagavan, M. R. (1990). *The technological transformation of the Third World.* London: Zed Books.

Kim, R. (1982). Development that is total and human. *Origins. 11. 8. 122.*

Mbiti, J. S. (1969). *African religions and philosophy.* Nairobi: East African Educational Publishers.

Metuh, I. E. (1991). *African religions in western conceptual schemes.* Jos: Imico

Onunwa, U. (1994). The individual and community in African Traditional Religion and society. *The Mankind Quarterly. 34. 3.* 249 – 260.

Unah, J. (2009). Ontologico – epistemological background to authentic African socio-economic and political institutions. A F. Uduigwomen (Ed.). *From footmarks to landmarks on African philosophy* (264 – 278). Lagos: O. O. P.

Abanuka, A. (1994). *A new essay on African philosophy.* Nigeria: Spiritan.

Edeh, E. (1983). *Towards Igbo metaphysics.* Chicago: Loyola University Press.

Ijiomah, C. (2005). African philosophy's contribution to the dialogue on reality issues. *Sankofa: Journal of the Humanities. 3. 1.* 81 – 90.

Wirendu, K. (1998). How Not to Compare African Thought with Western Thought. *African Philosophy: An Anthology* (pp. 190-210). Nigeria: Blackwell Publishers.

Asouzu, I. I. (2004) *The methods and principles of complementary reflection in and beyond African philosophy.* Calabar: University of Calabar Press

Asouzu, I. I. (2007a). *Ibuanyidanda: New complementary ontology. Beyond world immanentism, ethnocentric reduction and impositions.* Munster: Lit Verlag.

Asouzu, I. I. (2007b). *Ibuaru: the heavy burden of philosophy, beyond African philosophy. Studies in African philosophy series.* Munster: Lit Verlag.

Kanu, I. A. (2015a). *Igwebuike as the consumate foundation of African bioethical principles.* A paper presented at the International Conference on Law, Education and Humanities. 25th -26th November 2015 University of Paris, France.

Kanu, I. A. (2015b). Igwebuike as an ontological precondition for African ethics. A paper presented at the International Conference of the Society for Research and Academic

Excellence. University of Nigeria, Nsukka. 14th -16th September.

Kanu, I. A. (2016a). *Igwebuike as the Expressive Modality of Being in Igbo Ontology*. A paper presented at the Hummingbird Publication and Research International Multidisciplinary Conference held at the Kwara State University, University Main Auditorium, Malete, Kwara State, 30th June.

Kanu, I. A. (2016). *Igwebuikecracy: An Igbo-African Participatory Socio-Political System of Governance*. A paper presented at the Hummingbird Publication and Research International Multidisciplinary Conference held at the Kwara State University, University Main Auditorium, Malete, Kwara State, 30th June.

Nwajiuba (1999). "The relationship between material social status and academic performance of secondary school students in Owerri Educational Zone". Med Thesis, Department of educational Foundations and administration, Imo State University Owerri.

Onwuliri, C. E.C. (2008). The Church as an agent of progress and development. In I. Onyeocha (Ed). *The Church as agent of progress and Development, CIP Jubilee Essays* (pp. 70-83). Owerri: Imo State University press.

TOWARDS AN AFRICAN BIOETHICS

Introduction

Bioethics has become a common place and a burgeoning interdisciplinary field of scholarly investigation, which has in the past decades migrated from bedside consultations to public policy debates and wider cultural and social consultations that privilege all discourse about everyday life issues. A cursory glance at the historical evolution of bioethics as a discipline, reveals the emergence of a couple of trends, such as the advent of the quest for regional characterization, giving birth to culturally rooted bioethical perspectives. Majority of existing studies in this area of scholarship presents bioethics as though it were a field of enquiry that is the prerogative of the Western world, dominated by Western idiosyncrasies and eccentricities. There is also the perspective that African bioethics is a myth; a perspective that is furthered by ideological race classification, the slave trade and colonialism.

This work, therefore, focuses on developing an African bioethics, for the enhancement of African authenticity and

identity. The conviction is that there is an African bioethics that is based on the African cultural heritage. If Africans must retain their identity and be authentic, they must be true to themselves. Given a religious-oriented culture, this would mean having to be guided by a religio-cultural perspective on particular bioethical issues, in such a way that the African tradition, history and cultural heritage are taken cognizant of and respected. This is the gap this research fills. This study adopted the multidisciplinary approach, since bioethics is a multi-disciplinary discourse. The data collected were thoroughly analyzed using the phenomenological method of interpretation.

The African worldview was also studied, from which the ontological foundations of African bioethics was generated. The ontological foundations, served as a basis for the effectuation of African bioethical principles. The researcher therefore concludes, based on evidence, that there is an African bioethics; and recommends the need to strengthen bioethics education and research in various institutions in Africa, and to develop a vibrant bioethical discourse and critical thinking among African scholars for the solving of bioethical dilemmas that Africans encounter every day. The significance of this research is the fact that it has unveiled the richness of the African cultural heritage in relation to bioethics. It will serve as a stimulus for further research in the area of African bioethics, and as a basis for developing critical thinking in the field of bioethics in Africa that would outline a descriptive analysis of ethical and moral values as rooted in authentic African traditions and cultures, which can provide a helpful framework for ethical decision making.

The Meaning and Nature of African Bioethics

African Bioethics can be defined as a field of study that concerns itself with the evaluation of ethical issues arising in medicine and the cultural practices in Africa from an African perspective. Such an evaluation springs from an African background and belief. African categories will therefore constitute the instruments or principles for analysis and which shapes and transforms the meanings attached to the experience of life, health and illness. For instance, when Africans are reflecting on moral issues such as abortion, organ transplant, euthanasia, cloning, suicide etc., they would appeal to the shared moral traditions and ethical values that are implicit in beliefs and practices of African culture. These values, rooted in authentic African culture and traditions will further provide the base and framework for ethical decision making.

The sources of Africa bioethics, according to Mbugua (2009) and Andoh (2012), would therefore include popular sayings, songs, mythology, tales, folklore, proverbs, maxims etc. This is what gives it its identity as African bioethics, and it is also from this that it draws its authenticity. African bioethics must be peculiar to Africa and common to Africans. This is necessary because, if African bioethics is not peculiar to Africa or to Africans, there would not be much sense in distinguishing African bioethics from non-African bioethics. The peculiarity, which is a shared feature in African bioethics by Africans, becomes the unity of African bioethics. If there must be a peculiarity and unity

in the science of African bioethics, then we must turn to the Africa worldview as its indispensable source.

Although the concept of African bioethics is in existence, a couple of factors impede its flourishing like Western bioethics, or the bioethics of other cultures or peoples. Among these reasons are: inadequate funding by the government and non-governmental organizations in the area of African bioethics, African governments are not interested in this kind of research. The political will or commitment isn't there; many Africans consider bioethics a Western discipline as its concerns, in relation to high tech, are still far from Africa. These shortfalls notwithstanding, Africans need to develop critical thinking in the area of bioethics within Africa, which will require bioethicists from Africa to root their enquiries on ethical values in African traditions.

African Bioethics as a Quest for Regional Characterization

Mbugua (2009) observed that bioethical principles promoted in the West, precisely the United States of America, which emphasize respect for autonomy, beneficence, non-maleficence and justice are non-existent and unacceptable in other cultures. It is in this regard that Ryan (2004) avers that:

> Critics bearing the concerns of feminism, religion and multiculturalism have registered their discontent with the state of contemporary bioethics in the U. S. A. Heavily indebted to the principles-based method that became popular through James

> F. Childless and Tom L. Beauchamp's influential text, *Principles of Bio-medical Ethics,* bioethics has been called to task for its emphasis on rights and duties over the development of character and virtue, as well as its relative attention to social, religious and cultural features of moral experience and moral agency. (p. 158).

Hongladarom (2003) while arguing for Asian bioethics wrote:

> Hence it is no longer adequate to limit the debates and discussions in bioethics only within the Western perspectives. As long as countries, notably in Asia, enter into the advances of biotechnology and the life sciences, these countries need to find their ways of solving the problems as well as carry on the debates and discussions as partners in the global dialogue (p. 1).

Crawford (2001), focusing on Hindu bioethics, further agued that:

> In fact, the new pluralistic approach to world cultures is introducing us to several religious and philosophical alternatives from outside the Anglo-American West. Just as alternative medicine I becoming recognized and respected, and is been incorporated into mainstream medicine, there is a growing admission that the ethical problems we face today have dimensions that are not adequately addressed... (p. 25)

The promotion and globalization of this kind of bioethics, basically built on Western categories of thought and, which relies heavily on Western analytical philosophy, has been interpreted as bioethical imperialism or colonialism. Confronted by the question of identity and authenticity in bioethical discourse, Fan (1997) asked "Ought bioethics in East-Asia to use the same approaches (assumptions, principles, theories, styles, methods, concepts) as bioethics developed in the West, or ought it to reflect a specifically East Asian approach to the subject?" (p. 310). Sakamoto (1995) while addressing the brain death debate in Japan maintained that "'Our bioethics' should be based on our own culture and, therefore, it should be somewhat different from the Euro-American ones" (p. 30). De Castro (1999) addresses it as an issue of identity. He wrote:

> The issue appears to be one of identity. The crucial values are authenticity and integrity. The unarticulated argument is that if we are to be authentic, we must be true to ourselves. Given a religion-oriented culture, this could mean having to be guided mainly by religious thought on the various topics of bioethics. Where there is no dominant religious worldview, 'being true to ourselves' could mean being cognizant and respectful of one's traditions, history and cultural heritage (p. 230).

He argued further:

> People also need to retain their integrity as a group. They must uphold the shared values that unite them. They must seek recognition of their identity

> as a people. To be remiss in this responsibility is to participate in the annihilation of their identity. What seems to be at stake, then, is the survival of an identity- in a way, the preservation of a cultural self. (p. 231).

From the foregoing, Gbadegeshin (2009) thus calls for a trans-cultural bioethics which is characterized by:
1. openness to and effort to understand the cultures and values of other people;
2. the development of a compendium of values and belief system across cultures;
3. the promotion of intercultural dialogue on the critical analysis of those values and belief systems;
4. identification of set of common values that transcend particular cultures; and
5. utilization of this set of common values in the development of bioethical principles and standards that all cultures can embrace.

Gindro (1995) pointed out the relevance of such a study:

> Nowadays, physicians and therapists must face new problems rising from the great migration of populations, and consequently the deep mixing of cultures. Until a short time ago, Western medicine imposed its universal validity primarily through the diffusion of missionaries throughout the world. In the different countries touched by colonialism, the local cultural expressions were naturally considered primitive, and therefore, of a lower level. (p. 6).

Disciplines of African Philosophy

This notwithstanding, as much as it is relevant to employ unique responses to bioethical issues for the maintenance of integrity and authenticity, it is also significant to find out points of contact for a cross-cultural communication. Cross-cultural communication is important because there are bioethical problems that are common to all peoples. This would further help others to learn from the mistakes of others, and also share concepts without loss or cost.

The 'Globalization' of Western Bioethics: A Process or a Product

The concept globalisation is from the words *globe, global, globally*, which are dictionary words, contrary to *globalisation* which is yet to find its way into the English dictionary. However, from the root words, globalisation can be defined literary as an attempt to make global. Tandon (1998) observes that globalisation is a new feature of the world economy and one of the most challenging developments in the movement of world history. It has continued to attract increased scholarly and analytical attention throughout the globe. Ohiorhenuan (1998), argues that it is currently affecting the physiology of the African society through its imposition of constraints on policy-making autonomy or independence of Africa vis-a-vis our capacity for authoritative allocation of scarce and critical societal values or resources among other functions.

According to Fafowora (1998), globalisation refers to the process of the increasing economic, political, social and cultural relations across international boundaries. It deals

with increasing the breakdown of trade barriers and the increasing integration of world market. Ohuabunwa (1999), gives further insight when he defined globalisation as an evolution which is systematically reconstructing integrative phases among nations by breaking down barriers in the areas of culture, commerce, communication and other fields of endeavour. It pushes for free-market economics, liberal democracy, good governance, gender equality and environmental sustainability among other holistic values for people.

Taking the global character of globalisation, other scholars see it as a product manufactured in the West and to the Third World to explode and cause damage. For instance, McEwan (1990) sees globalisation as the spread of capitalism. It is an imperial policy and the final conquest of capital over the rest of the world. Akinde, Gidado, Olaopa (2002) avers that it is a one-arm banditry and exploitative antecedents of capitalism which, by its nature cannot exist without parasitic expansion, its immutable and primary focus is to exploit African resources, disintegrate its economies and incorporate it into the international capitalist economy. Madunaga (1999), opines that as a concept, it was not handed down from heaven, it was not decreed by the Pope, it did not emerge spontaneously. It was created by the dominant social forces in the world today to serve their specific interests. Simultaneously, these social forces gave themselves a new ideological name the- "international community"- to go with the idea of globalisation. From this perspective, scholars such as Ryan (2005), Wasunna (2005) and Andoh (2011) have accused the west of globalizing her Euro-American bioethics,

Disciplines of African Philosophy

or as imposing her bioethics on the rest of the world, especially the third world. Tangwa (1999) in an article which he titled *Globalisation or Westernization? Ethical Concerns in the Whole Bio-Business* lamented that "the globalization of Western technology should not be accompanied by the globalization of Western ways of thinking and acting, Western ways, manners and style of doing things, Western idiosyncrasies and eccentricities" (p. 169).

This actually raises the question as to if globalisation is a product or a process. It is in this regard that Agbo (2010) avers that:

> We have conceptualized globalisation as a 'product' exported to the African with sinister motives, we have assumed in an incurable nihilistic pessimism, that somebody, some people, somewhere (in the west), sometime (in distant and recent times) have sold us this 'globalisation' and unfortunately, we had had to buy it without what Kwasi Wirendu would refer to as an 'open utilitarian eyes'. Globalisation within the African intellectual context, has acquired terms that are nearest in meaning to it: universalization, internationalisation, liberalization, capitalization, Westernization, Europeanization, Americanization, re-colonization, imperialization… re-enslavement, etc… This, to me represents an irrational moralization of an amoral concept. The propagandist, emotional, and psychological engagement of globalization is, therefore, in my opinion both uncharitable and meaningless. (p. 26).

Omoregbe (2007), agreeing with Agbo wrote that, "globalisation was not something that was planned or decided at a conference table by certain states or individuals. Rather, it is a natural process of socialization, a process of world history, a phase in the world historical process" (p. 152). In the same vain, Asouzu (2007) avers that, "It would be a very erroneous idea to imagine that globalisation is the creation of any culture. It is rather, a necessary consequence of the character of our being as relative subjects seeking full actualization" (p. 382).

Rather than keep complaining without fruit, African scholars, and indeed other third world scholars, especially in the area of bioethics need to understand globalization as a process in which all the world is involved in. Agbo (2010) describes globalization as a process "generated by all, in all and for all" (p. 27). It is not a product manufactured in Europe and America, but rather a process that Africans will have to find a better way of getting involved in or lose out. Africa has no option of not involving herself in the process of globalisation, Africa must globalize and be globalized. The more African scholars in bioethics write, the more African ethics would contribute to the pool of cross-cultural bioethics. What African bioethics scholars should be talking about is on how best African can be involved in the globalizing world rather than being afloat in the globalizing tide. There is a difference between "contributing to globalization and being globalized" from just "being globalized, without contributing much". African bioethics is at the verge of the later.

As the world moves on, Africa cannot tell the other parts of the globe to wait for her or return to meet us behind where we are. We rather must move faster to meet up economically, politically, socially, culturally, educationally and other wise. To begin to blame globalisation as though it were a moral being is a waste of effort; no nation will be judged for globalizing, for that would mean blaming a nation for being part of the global world. Thus De Chardin (1959), would refer to globalization as the 'omega point', where the goal of convergence would be achieved. In Hegel, it is the return of the 'Absolute Spirit' and in Karl Marx, it is the recognition that motion is the existent form of matter, that reality exists and develops, through dialectical contradictions, in interrelatedness, and interractiveness. What African scholars should be doing rather than blame the West is to develop an African bioethics and use the modern means of communication so as to bring their product to the global industry of bioethical research.

Specific Issues in African Bioethics

There are so many issues for discussion in the area of bioethics, and these issues continue to increase in number and complexity with the developments in the area of medical science and technology. Thus Levine (2008) avers that bioethics has attracted more attention with the enlargement of the ability of medical professionals to intervene in profound ways in the most fundamental processes of life and death. In this work, there is a particular focus on specific issues in the area of bioethics. Particular bioethical issues include Abortion, Environment, Genetic Engineering/Human

Cloning, Suicide, Euthanasia, Organ Transplantation, HIV AIDS, Health Care and Female Genital Mutilation. They are considered bioethical issues because they annihilate the *bios* (Greek), that is, the life of human beings. And the idea of ethics comes in here because it deals with human actions (by one's own action or the action of another person). It is in this regard that ethics is considered a rational discipline that deals with the different aspects of human life, actions and activity in order to direct such an action or activity towards the good of human beings. Ethics will therefore, scrutinize these actions to identify the sources and roots of their fatalities, in order to redirect human actions towards self-actualization, rather than self-annihilation.

The Ontological Foundations of African Bioethics

Mutahi (2009) during his address at the International Conference on Bioethics at Egerton University, Kenya, said that:

> Africa faces bioethical challenges in research and technology especially as they relate to medicine and life sciences. Questions on human cloning, stem cell research, genetic testing, genetically modified organisms, and human organ donation continue to dominate public debate. All these issues directly touch on the wellbeing of human beings, with or without consideration of their social, legal and environmental dimensions. East African states and Africa as a whole have to take urgent independent

decisions on the application and utilization of these novel advances in science and technology. In depth understanding of the impact of these scientific activities on human beings, biodiversity and environment is critical, if we are to avoid disastrous consequences. (p. 1).

If Africa and Africans will take an independent decision; and if these decisions must really be independent, it must be defined by the particularities and peculiarities of Africa. Thus, these cannot but be based on the African ontology. The ontological foundations of African bioethics are the theological and philosophical foundations. The underlining principle of these foundations is the centrality of the spirit, springing from the fact that the African universe is dominated by spirits. These foundations are the pool from which African principles of bioethics could be generated.

These foundations include the earth goddess, the sacred days in Igbo ontology, sacred trees, reincarnation, concept of life, myths, sacred animals, concept of health, causality, community and person. However, how does these dimensions of Igbo-African ontology relate to bioethics or the preservation of human life? In relation to the environment, the idea of the earth goddess, sacred trees, sacred days and sacred animals contributed greatly in the preservation of the environment. Because the earth was regarded as a goddess and mother, she was treated with respect, love and solidarity. There were trees that were not cut, there were animals that were not killed, and there were days that people didn't go hunting, or fishing or farming,

because these days were considered sacred. In one way or the other these events and relationships with nature helped in conserving her and saved her from exploitation. If one violated any of these, it was taken that the gods would bring punishment upon him or the community. As a result, one saw himself as being affected when nature was affect. There was harmony in the relationship with nature.

When it comes to the issue of reincarnation, it gave life more meaning that many now think it has. Life was not conceived in mechanistic terms, with its bones as levers, with the heart as pump, with the lungs as bellows etc; the understanding of life as a clock, or life as a singular organization of matter. The human person is seen as the blessing of an ancestor; an ancestor returned to life. Thus the meaning of life was more profound; it begins not just at conception. Conception is only a physical manifestation of a gift that has come from the spirit world. The human person is seen as having a purpose. Thus the issue of wanted or unwanted pregnancy was not entertained. To destroy life is to work against the spirits or the spirit world from which the human person has come, and which has given purpose and sustains that life. The idea of causality in Igbo-African ontology brings in the presence of the spirits and gods. They can cause harm when taboos are committed, such as spilling of blood, and they could bless when the good is done. Thus health becomes a meta-empirical. This Igbo-African concept of causality and the afterlife, does affect her concept of organ transplant. The area of organ transplantation is an area where the principle of beneficence need to be developed. According to Ngari (2008):

For many African cultures organ donation could be translated as witchcraft. Usually organs from other persons were used in sorcery. Therefore, bearing an organ of a dead person meant possessing his or her spirits to some extent which can be manipulated. There is need to explain the modern scientific procedures on organ donation so that the African "world view" on the same and its ethics can be transformed The disposal of the human body after death was to be done in such a way that it was kept off the visibility of the people and could not be manipulated or maintained for other purposes rather than disposal. Any other use constitutes to taboo. Lack of proper disposal could lead to problems with the spirits of the deceased (Luo community among others). Donation of the body for medical research raises serious issues from an African perspective. There is need to create an awareness of the usefulness of biomedical research for the good of the human life and health. There is need to also demythologize the different African outlooks that may inhibit such practices in the advancement of knowledge on human organs and medicine. (p. 80).

This is an area where some adjustments would have to be made in the African concept of life, that the same life may be promoted.

The Igbo-African concept of life enhances it. It indicates that life has come from God, and this is evident in the

names that the Igbos give to their children, and also from Igbo mythology: it is *Chukwu* that gives life. It is a gift. And when this life is given, it is not a personal thing; it is welcomed by the community that gives the child its identity- the community gives the child his or her name; for the child realizes himself or herself within the community. Pregnancy in Igbo-African life is not just about the woman and her choices, it is a community affair. The community bears both the gains and loses. The *dramatis personae* include: the wife, the husband, neighbours, spirit forces and the unborn baby. The whole pregnancy rite is fashioned to facilitate the birth of the child and to protect the mother and child from evil forces. The Igbo-African world welcomes children, loves them and protects them.

African Bioethical Principles

Based on the challenge posed by the President of the International Association of Bioethics, this section attempts to develop a different version of principlism for bioethics that incorporates the salient features of African ethics.

a. Respect for Persons

A fundamental principle in African bioethics is respect for persons. This principle is anchored on the African concept of the nature of the human person. The African sees the human person as possessing a dignity that is inseparable from his being. The African understands the human person as a gift from God, and this theology is echoed in the Nri myth of the origin of life. The nexus between God and

human beings, makes the human person a theomorphic being, and explains why the Igbos say, *ndu sin a chi* (life is from God). It is also on this basis that the human person is respected right from conception.

b. Beneficence

This, in ordinary English, refers to an active goodness, kindness or charity. Beneficent actions are those that benefit other persons, like love, altruism etc. It is the opposite of maleficence. It claims that we have a duty to help others in realizing their interests when we can do that without being at risk.

c. Non-Maleficence

Two words are involved here: none and maleficence. Maleficence means an active wrongdoing or hurt. It is the opposite of beneficence. Thus, the words put together as non-maleficence would mean keeping way from harming or hurting. Shannon (1993) wrote that "nonmaleficence is a technical way of stating that we have an obligation not to harm people. One of the ancient technical principles is 'First of all, do no harm' (*primum non nocere*) derived from the Hippocratic tradition. If we can't benefit someone, then at least we should do him or her no harm" (p. 6).

d. Harmony

The African universe is governed by the spirit of harmony. There is harmony between the physical and spiritual worlds and the human person who is at the centre of Igbo-African

universe relates with every dimension of this universe. He relates with the spirit world through the diviners and medicine men and women. This harmony is anchored on the spiritualized nature of the African universe.

e. **Community/Solidarity**

The idea of community or solidarity is linked to the principle of harmony, as the African sense of community and solidarity is the harmony that emerges from the relationships in the society. According to Ruch and Anyawu (1981), "Family ties are very tightly knotted with taboos, interdicts and cross-checks. This web maintains the harmony of the group" (p. 144). These principles that spring from the very heart of African ontology guide and shape bioethical principles for the preservation of the African identity and authenticity.

Conclusion

Debates in the area of bioethics have now become global in character. This new development is based on the fact that advances in the area of biotechnology and life sciences are so rapid and wide ranging that it quickly spans the globe, and most importantly, different cultural traditions in a world need to find their solutions towards these problems. The search for an Igbo-African bioethics, with an Igbo-African identity is a search for solutions to bioethical problems from the Igbo-African cultural tradition; it could also stand up to the alleged imperialism of Western bioethical principles or concepts, which are growing in significance in the face of globalization characterized by the dizzying advances in the

areas of communications and biomedical technology. In our globalizing world, a research on bioethics, with Africa as a context, will count as Africa's contribution to the globalizing process rather than being afloat in the globalizing tide. There is a difference between "contributing to globalization and being globalized" from just "being globalized, without contributing much". In a world characterized by increasing cross-cultural encounters and ethical pluralism, a development in the area of Igbo-African bioethics can now drive for universal understanding and acceptance. This acceptance must be built on striking a balance between the attention that needs to be given to the similarities and the attention that needs to be given to the differences. The Igbo-Africans and other colleagues of the global community can indeed learn from one another, through the sharing of one another's viewpoints and traditions, which in the end will enrich us all.

Andoh (2011) had argued that to reason well ethically would require three skills:
1. The knowledge of the traditions of ethics, as well as theories and strategies that have been historically used to analyze ethical issues;
2. The capacity to understand our own cultures, its values, patterns of thought and behavior;
3. The awareness of our biases and proclivities to help us note our weaknesses and failings, and to help us resist deceit.

This piece on Igbo-African bioethics has studied the traditional perspectives on bioethics. It has further tried

to view the traditional perspectives through the lens of an Igbo-African culture, it is hoped that this work would sustain reflective and critical perspectives for meaningful ethical discussions in science and technology. Furthermore, it is also hoped that this piece would help the African form an African consciousness and to have an African *ars Vivendi* developed from their own sound culture, traditions and practices.

References

Agbo, J. N. (2010). Is globalisation a process or a product? In A. B. C. Chiegboka, T. C. Utoh-Ezeajugh, and G. I. Udechukwu (Eds.). *The Humanities and Globalization in the Third Millennium* (pp. 26-39). Nigeria: Rex Charles and Patrick.

Akinde, S. T., Gidado, T. O. and Olaopa, O. R. (2002). *Globalisation, its implications and consequences on Africa*. Retrieved 1/7/2012. http://globalisation.icaap.org/content/v2.1/01_akindele_etal.html

Andoh, C. (2011). Bioethics and the Challenges to Its Growth in Africa. *Scientific Research: Open Journal of Philosophy*. 1. 2. 67-75.

Asouzu, I. I. (2007). *Ibuanyidanda: New complementary ontology. Beyond world immanentism, ethnocentric reduction and impositions*. Munster: Lit Verlag.

Crawford, S. C. (2001). Hindu Bioethics for the Twenty-First Century. *Journal of Hindu-Christian Studies*. 14. 9. 25-30.

De Castro, L. D (1999). Is there an Asian bioethics? *Bioethics* 13. 3/4. 227-230.

De Chardine (1959). *The phenomenon of man*. London: Collins.

Fafowora, O. O. (1998). Management imperatives of globalisation. *Management in Nigeria: A Journal of Nigerian Institute of Management. 34, 2-4.* 5-9.

Fan, R. (1997). Self determination Vs Family determination: Two incommensurable principles of autonomy. *Bioethics. 11.* 309-322.

Gbadegesin, S. (2009). Bioethics and culture. In Helga, K and Singer, P. eds. *A companion to bioethics* (pp. 45-60). Maiden: Blackwell.

Gindro, S. (1995). Transcultural issues in ethics of health care. *EACME News. 4.* 6-8.

Hongladorom, S. (2003). *Asian Bioethics: What is it? And is there such a thing?* A paper presented at a symposium organized by the Japanese Ministry of Education, Culture, Sports, Science and Technology on Dialogue and Promotion of Bioethics in Asia. At Kyoto, Japan, September 22-23.

MacEwan, A. (1990). *What is new about the new international economy?* Mimeo: University of Massachussets.

Madunaga, E. (1999). Globalisation and its victims. *Guardian July 26.* 53.

Mbũgua, K. (2009). Is there an African bioethics? *Eubios Journal of Asian and International Bioethics. 19. 4.* 2-5.

Mutahi, K. (2008). *Opening Address for the Conference on Bioethics.* An address presented at the International Conference on Bioethics Organized by the UNESCO Regional Centre for Documentation and Research on Bioethics at Egerton University, 12-14 August.

Ngari, S. M. (2008). *Bioethical issues in African culture and religion*. A paper presented at the International Conference on Bioethics Organized by the UNESCO Regional Centre for Documentation and Research on Bioethics at Egerton University, 12-14 August.

Ohiorhenuan, J. F. E. (1998). The South in an era of globalisation. *Cooperation South, 2*. 6-15.

Omoregbe, J. (2007). *Social-political philosophy and international relations*. Lagos: Joja educational Research and Publishers.

Ruch, E. A. and Anyawu, K. C. (1981). *African philosophy*. Rome: Catholic Books Agency.

Ryan, M. A. (2004). Beyond a Western bioethics. *Theological Studies. 65.* 158-177.

Sakamota, H. (1995). New initiatives in East Asian bioethics. *Eubios Journal of Asian and International Bioethics. 5.* 20-30.

Shannon, T. A. (1993). *Bioethics: Basic writings on key ethical questions that surround the major modern biological possibilities and problems.* New Jersey: Paulist Press.

Tandon, Y. (1998). Globalisation and Africa's options. *AAPS NewsletterHarare. 3. 1.*

Tangwa, G. (1999a). Globalization or westernization? Ethical concerns in the whole bio-business. *Bioethics. 13.* 10-16.

Wasunna, A. (2005). The development of bioethics in Africa. In M. Patrao (Ed.). Bioeticas na evolucao das sociedades (pp. 331-334). Coimbra: Grafica de Coimbra.

TOWARDS AN AFRICAN METAPHYSICS

Introduction

One of the fundamental areas in philosophy is metaphysics. It is very fundamental that virtually every philosopher in the history of philosophy gave some time to metaphysical discourses. It is, therefore, not surprising that Anah (2005) avers that it is a field of inquiry that has remained evergreen right from the Pre-Socratic period to the Contemporary Era of the development of philosophy. According to Omoregbe (2002) the metaphysical question of being was set in an articulated motion by Parmenides when he argued that whatever is, is being. He further said that being is one, eternal and unchanging, meaning that whatever changes is not being. This notwithstanding, Russell (1975) observes that Heraclitus of Ephesus was chiefly famous in antiquity for his doctrine that everything is in a state of flux, as such, being is characterized by flux. Plato, while disagreeing with Heraclitus on his doctrine of flux, agrees with Parmenides that reality is eternal and unchanging, however differs from Parmenides in arguing that being is multiple rather than

one; and these are the forms in the Platonic World of Forms. Aristotle who defines Metaphysics as the study of 'being qua being' identifies being with God, it is therefore not surprising that in Aristotle, Metaphysics becomes theology.

The emergence of the Medieval Epoch, in the Contention of Izu (2009), did not alter the centre-piece of metaphysical enquiry. St Thomas Aquinas followed Aristotle in identifying being with God, an argument which Duns Scotus rejects and proposes that creatures are beings in the real sense of the word and not in an analogical sense as Aquinas had taught. During the Modern Period, the problem of being did not feature prominently as philosophers were more concerned with the problem of substance. The problem however emerged in Hegel, Jean-Paul Sartre and Gabriel Marcel, in whom being became a mystery.

These notwithstanding, in recent times, African thinkers have tried to define metaphysics in terms of the African ontology. Focusing on being, which is the fundamental concern of metaphysics, they have tried to move away from the elusive and unsubstantive concepts employed by their Western predecessors and counterparts. They have tried to define being using the categories common to the experience of the African. For African scholars like Edeh (1985), he moved through the *onye* hypothesis and arrives at the *ife* hypothesis of being. For Njoku (2011), being is *chi*. However, for Iroegbu (1995 & 2004), *to be* is *to belong*, thus *Being* is *Belongingness*. This piece would focus on structuring African metaphysics. It is a study that would build on previous literatures on African metaphysics and inspire further writings in this regard.

Meaning of African Metaphysics

The word metaphysics was first used by Andronicus of Rhodes, who was then the editor of Aristotle's work, around 70 BC. It is derived from two Greek words, *Meta* which means after, and *physika* which means physics. Brought together, it would literally mean that which is after physics. While Andronicus was editing Aristotle's works, he realized that some were on physics, that is, on physical issues, and so he named them Physics. He also realized that some were on non-physical matters, but without a title. Since they were given no title by Aristotle, Omoregbe (2002) posits that he placed them after the work physics, and since he did not know what to call them, he named them "after physics" (*meta physika*), that is, the treatises that come after those dealing with physics. This was how the word metaphysics emerged.

Eventually, it came to be understood as beyond the physical world, and thus, a discipline dealing with realities that lie beyond the physical world. This concept can again be misleading because metaphysics as a branch of philosophy studies the totality of being, in its nature and structure. It is in this regard that Omoregbe (2002) argues that what metaphysicians have been trying to do down through the ages is to give a comprehensive account of the whole of reality, its nature, its structure, and the place of the human person in the universe as well as in the totality of reality. It is an endeavour to frame a coherent, logical, necessary system of general ideas in terms of which every element of our experience can be interpreted (Whitehead, 1929). In the study of metaphysics, a couple of problems have emerged: the problem of being,

the problem of essence and existence, universals, appearance and reality, change and permanence, causality, freedom and determinism, unity and diversity and the problem of substance.

While some African philosophers have denied the possibility of such a thing as African metaphysics or in fact, African philosophy, philosophers like Houtoundji (1995). Some others have attempted at proving the possibility of not just African philosophy but African metaphysics. Edeh (1985) *in his Towards an Igbo Metahysics*, Ozumba (2004) in his *Towards an African Traditional Metaphysics,* Adeofe (2004) in his *Personal Identity in African Metaphysics*, Ekanola (2006) in his *Metaphysical Issues in African Philosophy,* Nwachukwu-Agbada (2008) in his *The Influence of Igbo Metaphysics on the Writings of Chinua Achebe*. made very concrete effort in this regard. However, his perspective on African metaphysics does not adequately capture what may be satisfactorily referred to as African metaphysics. Defining African metaphysics, Ozumba (2004) writes:

> African metaphysics should be seen as the African way of perceiving, interpreting and making meaning out of interactions, among beings, and reality in general. It is the totality of the African's perception of reality. African metaphysics will therefore include systematization of as African perspective as it relation to being and existence. This will embrace the holistic conception of reality with its appurtenance of relations, qualities, characterizations, being and its subtleties universals, particular, ideas, minds, culture, logic, moral, theories and presuppositions. (p. 1).

Disciplines of African Philosophy

Focusing on its nature, Ozumba (2004) continues:

> African Metaphysics is holistic and interrelated. The logic of their metaphysics underpins their standard and expectations. This is not to go with the impression that all African communities share the same standard even though the standard is community based. Borrowing from Quine, each community operates from a background theory that penetrates its perception and metaphysics of reality. If you see thing other than the way the community sees them, they will demean your understanding and systematize with your "alienness." What we intend to do is to abstract the general orientation of the African in their metaphysics and general views about certain aspects of reality. Here, we adumbrate the African's perception of the following aspect of reality, viz: personality, Being, Substance, Causality, immorality of the soul, witchcraft, Appearance and Reality. (p. 1).

Dimensions of African Metaphysics

a. **Being**

In African ontology, being is that which is; however, considered in terms of concreteness rather than unsubstantiveness. Being can will be subsumed into the following categories:

Muo (Spirit): *Muo* as a force has categories of forces. It includes God, the divinities and spirits. God is at the apex of the Muo category as the source of all forces, Tempels (1959) wrote, "Above all force is God... It is he who has force, power, in himself. He gives existence, power of survival and of increase, to other forces. In relation to other forces, he is he who increases force" (p. 29). He wrote further, "He knows all forces, their orderings, their dependence, their potential and their mutual interactions" (p. 34). His existential cause is within himself and sustains resultant forces. The subsistence and annihilation of other forces are within his power alone. While other creatures can paralyse, diminish or stop the operation of another being's vital force, they cannot stop it to exist entirely, only God can. After the Supreme Being are divinities. They are intermediaries and share aspects of the divine status. Awolalu and Dopamu (1978) refer to them as the executive heads of various divine departments in the Supreme Being's monarchical government. There are also myriads of spirits, benevolent and malevolent spirits that occupy the African universe. After death, two groups of spirits emerge: the benevolent spirits, known as the ancestors. They are a greater force than human beings.

Mmadu **(Human Being):** The human person (*Muntu*) is a vital force endowed with intelligence and will. Although God is the source of vital force, man according to Tempels (1959) is the sovereign

vital force in the world, ruling the land and all that abides in it, however, "his fullness of being consist in his participation to a greater or lesser extent in the force of God" (p. 47) who possesses the supreme force. He also shares an ontological relationship with his patrimony, relations and land. He has a will to choose between good and evil, which might be life giving or life destroying. Man is the centre of the universe, including the world of the dead. Tempels wrote that "man is the supreme force, the most powerful among created beings" (p. 46). He can renew his vital force by tapping the strength of other creatures. He wrote further, "Each being has been endowed by God with a certain force, capable of strengthening the vital energy of the strongest being of all creation: man" (p. 22).

Anu **(Animal, tame and wild):** This category of being comprises forces not endowed with reason. They are ruled by instincts. They are all under the force of man and exist for man. According to Tempels, "In fact even inferior beings, such as inanimate beings and minerals, are forces which by reason of their nature have been put at the disposal of men, of living human forces, or of men's vital forces" (p. 31). In another text, he wrote, "These lower beings exist, by Divine decree, only for the assistance of the higher created being" (p. 46). They are used to feed human beings and also for offering sacrifices to God, divinities and the ancestors.

***Ife* (things):** Edeh (1985) avers that "the Igbo word *ife* primarily means thing, anything material or immaterial. It is used to refer to a happening, an event, an occurrence. *Ife* can also be affixed to any adjective to mean specific things" (p. 95). For instance, *ife obuna* (anything), *ife ebube* (thing of wonder), *ife ojoo* (bad thing), *ife oma* (good thing). Ife as a force cannot act for itself, and thus can only become active when a greater force like God, divinities, spirits and man act on them. They have no will of their own and thus depend on the will of a greater force.

***Ebe* (Space):** Space talks about place. It is the relation of distance between any two bodies or points. It responds to the question of where. For instance, where did you see Emeka? Where did you pick-up Nnamdi? Where was the sacrifice offered? According to Ijiomah (2005) space in Igbo ontology consists of three levels: they are the sky, the earth and the underworld: "the sky is where God *Chukwu* or *Chineke* and angels reside; the earth where man, animals, natural resources, some devils and some physical observable realities abide; and the underworld where ancestors and some bad spirits live" (p. 84). Ekwealor (1990), corroborated Ijiomah's perspective when he categorized the Igbo-African universe into three spheres: *Elu-Igwe* or sky, *Alammadu* or the world of the living and *Alammuo* or the land of the spirits. The idea of space is known through sight, touch and supra-sensory insight.

***Oge* (Time):** Time responds to questions such as: when did you see Emeka? When did you pick-up Nnamdi? When was the sacrifice offered? Mbiti (1970) defined the African concept of time as "the composition of events which have occurred, those that are taking place now and those which are immediately to occur" (p. 17). Thus, the African concept of time is concrete and substantive. It is epochal, as it is wrapped around events and activities. Iroegbu (1995) avers that it is in time the Africans perform or fails to perform, and that his future and destiny are based on his use of time.

b. The Human Person and Immortality

According to Oduwole (2010), Yoruba scholars agree that the human person is made up of three basic elements: *Ara* (body), *Emi* (breath) and *Ori* (soul). This is also true of the constituents of man in Igbo ontology: *Obi* heart or breath, *Chi* destiny, *Eke* or *Agu* ancestral guardian. Idowu (1962) describes the body as the concrete, tangible thing of flesh and bones which can be known through the senses. As regards the *Emi,* he describes it as spirit, and this is invisible. It is that which gives life to the whole body and thus could be described through its causal functions: Its presence in the body of a person determines if the person still lives or is dead. According to Oduwole (2010), the body is the creation of *Orisha nla* (Arch-divinity). He was assigned by *Olodumare* (the Supreme Being)

to mould the body of human beings. It is only the Supreme Being that puts the spirit into the body so as to give it life. Yoruba philosophy on the human person does not end with the body and spirit, there is a third element called the soul. The soul affirms that the human person already has individuality in the spiritual world before birth. From this understanding, life does not begin with birth, it begins as soon as one acquires the soul which defines a person's individuality. The soul of the human person begins to live even before there is a body for its abode.

c. The Word

Jahn (1958) observes that the Word occupies a significant place in African philosophy. He avers that "All the activities of men, and all the movement in nature, rest on the word, on the productive power of the word" (p. 126). As such, Jahn (1958) avers that:

> If there were no word, all forces would be frozen, there would be no procreation, no change, no life... For the word holds the course of things in train and changes and transforms them. And since the word has this power, every word is an effective word, every word is binding. There is no 'harmless', noncommittal word. Every word has consequences. Therefore the word binds the muntu. And the muntu is responsible for his word. (p. 133).

Disciplines of African Philosophy

African medicine, talisman, magic, poison etc are only effective through the word. Thus, all African medicines are ineffective without the genuine power of the word. A man is not just cured by the medicine but by the words that issue forth from the mouth of the medicine man. Thus, the stronger a medicine man, the stronger his word and the stronger will his medicine be. Generally, the African has more faith in the power of the word than in the power of the substance given to him by the medicine man. Blessing, curse, magic, incantation, exorcism, etc are based on the power of the word. The word was with God at creation, for all things were created through the word, but with the creation of man, God has given the word to man, who unceasingly creates and procreates through the word. As God was able to say, "Let there be light and there was light", the African man is also capable of such utterance. Relying on Bantu philosophy, Jahn (1958) wrote, "The word force of one muntu is different from the word force of another: the nommo of Amma or Olorun or Bon Dieu is more powerful than the word of a living individual, or the nommo of an Orisha more powerful than that of one's death father. The hierarchy of the Bantu (men both living and dead), is ordered according to the force of each one's word. The word itself is force" (p. 133). As such, man can say 'let the moon fall down' and it would fall, unless a more powerful being by the force of its word had placed the moon there.

d. Witchcraft

Withcraft according to Okpalike (2012) is both a religion and a craft. It consists in magic, sorcery, augury, divination, necromancy, fortune-telling, clairvoyance, etc. Offiong (1991) avers that "It is a psychic act through which socially disapproved supernatural techniques influence events" (p. 78). It is described as psychic and supernatural because, as Nadel (1952) observes, their activities take place in a fantasy realm, which is intangible and beyond empirical verification. How does a person become a witch? Arazu (2003) insinuates that a person becomes a witch by eating a witchcraft substance, and once it is eaten, the witch compulsively engages in a kind of astral travel with the mission to destroy. One can also be a witch by marrying from a family of witches, or when a person is given birth to by a witch. They have the sole mission of propagating evil, and when they die, they become evil spirits.

Witches can infest another person with a disease beyond cure, eat the soul of a person; they can send flies or other insects to cause a disease in their victim, once the fly perches on the person, the effect manifests; they can dig holes and bury things which when matched by the victim would be infected by a dangerous disease. They can send hairs, nails, pins etc., into the body of their victims which would bring about ill-health. At night, their spirits can leave them to go and bite their victim or cause him or her harm. At

night, some of them can turn into all kinds of animals like lion to visit their enemies. They can turn into goats or pigs to destroy an enemy's farm. At the heart of all these is jealousy or tension between neighbours and even family members. Witchcraft, thus, becomes a way to revenge or to humiliate the other person who has been tagged the enemy. They spread evil spirits and create disharmony among people, and also the propagate immorality among people.

A witch cannot denounce being a witch. It is not learnt or gained by being possessed by a particular spirit, it is a way of life. This would therefore mean that a witch cannot be exorcized because it is not a case of possession, and they sometimes act even without knowing that they are acting or having control over their actions. According to Arazu (2003), witches observe some rudiments in their daily life like austerity, keeping away from the ordinary life-style and observing the ritual of their cult. They employ the instrument of divination for the carrying out of their purposes. They possess the ability to divine through crystal ball gazing, gazing into the pool, mirror etc. Divination is therefore a very fundamental part of witchcraft.

e. **Magic**

Offiong (1991) defined magic as "Those supernatural devices employed by man to achieve his end with the help of spirits and gods... Magic involves an attempt by man, through the aid of the gods or spirits, to tap

and control the supernatural resources of the universe for his personal benefit" (p. 33). These powers could be manipulated for both good and bad ends through the rituals of prayers, worship, sacrifices, among others. When it is directed towards a good end, it can be used to cure a sick person, foresee the future etc. However, when it is directed toward a bad end, it can be used to kill a rival, turn a suitor away, crumble a person's business, to make rain to fall, etc. In whichever case, objects such as charms, amulets, concoctions are used. There is also a great dependence on incantations, deep breathing, fasting, the reliance on prayers, fasting, worship, sacrifices, etc., speaks of a strong connection between magic and religion. However, magic differs from religion in the sense that its instrument of operation is manipulation rather than supplication without any address to the Supreme Being in a spirit of submission and appeal; it is not emotional and operates on a professional-client relationship. Just like in the case of divination, magic is an important practice in witchcraft.

f. Causality

If the question, 'Does anything just happen?' were put to an African, what would be his response? For the African, according to Aja (2001), the world is an ordered universe in which all events are caused and potentially explicable. Thus Gyekye (1987) maintains the doctrine of universal causation in the Akan-African world. The African does not just speak of

Disciplines of African Philosophy

mechanical, chemical and psychological interactions like his Western counterparts; he also speaks of a metaphysical kind of causality, which binds the creator to the creature. Reacting to the Western concept of chance, which believes that things could happen by chance, Ozumba (2004) argues that what they call chance is their ignorance of the series of actions and reactions that have given rise to a given event.

Although Gyekye (1987) maintains a universal doctrine of causality in African ontology, he emphasizes that in African causality, greater attention is paid to extraordinary events and not natural events or regular occurrences when issues of causality is discussed. Regular or natural events would include, rain during rainy season, drought during dry season, a pregnancy that lasts nine months, the growth of plants, catching of few fish at some particular times of the year etc. Such events do not constitute a problem for the mind of the African, because, as Gyekye argues "such events are held by them to be part of the order established by the omnipotent creator" (p. 77). They are empirical, scientific and non-supernaturalistic. They have been observed by people who now know that there is a necessary connection between such events, for instance, they know that during dry season, the river dries up, or that a child stays in the mother's womb for nine months before delivery. Extraordinary or contingent are those that engage the minds of Africans, and such events would include, a woman

being pregnant for more than nine months, drought during rainy season, a tree falling and killing a man. These events according to Gyekye have particular traits that make them mind disturbing, "They are infrequent and hence are considered abnormal; they are discrete and isolated; they appear to be puzzling, bizarre, and incomprehensible; they are not considered subsumable under any immediate known law of nature" (p. 78). The events are deemed insufficient to explain their causes, thus, the ultimate cause of the event is sought. The interest is not on what has happened but why it happened. Thus, not that the tree has fallen, but why it fell on a particular man and not on the ground or on any other man.

Conclusion

To capture the entirety of African metaphysics just in a work of this kind would be quite difficult to achieve. This is because, the concern of metaphysics which is being- covers the entirety of reality and therefore, very broad. This explains why most African philosophers, rather than deal with African metaphysics as a theme with multiple sub-themes would prefer to deal with only a theme of metaphysics as their subject of inquiry. This also explains why, while there are several books on God, the person, immortality, the soul, etc, there are only a few books on African metaphysics. This work has made, not an exhausted research on African metaphysics, but has rather contributed to the corpus of literature now referred to as African metaphysics, hoping that more writings may be inspired in this direction.

References

Adebola B. Ekanola (2006). Metaphysical Issues in African Philosophy. In Olusegun Oladipo (ed.), *Core Issues in African Philosophy*. Hope Publications

Aja, E., *Metaphysics: An Introduction*, Enugu: Donze, 2001.

Alfred North Whitehead, *Process and Reality*, New York: Macmillan, 1929.

Andre Anah, "Belongingness: A Redefinition of Being", In *Father Kpim: Philosophy and Theology of Pantaleon Iroegbu* (Ibadan: Hope Publications, 2005), p.240

Arazu, R. C. (2003). *Man know thyself*. Enugu: SNAAP

Awolalu, J. O. and Dopamu, P. O. (1979). *West African traditional religion*. Ibadan: Onibonoje Press and Book Industry.

Bertrand Russell, *History of Western philosophy* (London: George Allen and Unwin Ltd, 1975), p.59

E. P. Edeh, *Towards an Igbo Metaphysics* (Chicago: Loyola University Press, 1999), p.94-97

Ekwealor, C. C. (1990). The Igbo world-view: A general survey. E. Oguegbu (Ed.). *The Humanities and All of Us* (pp.29-33). Onisha: Watehword.

F. O. C Njoku, *The Identity of the Particular: An African Basis for Philosophy, Science and Human Development*. A paper presented at the second International conference on Philosophy, Science and Human Development, organised by the Department of Philosophy, University of Nigeria, Nsukka, 30th November 2011-3rd December 2011, pp.9-12.

Gyekye, K., *An essay on African philosophical thought: The Akan conceptual scheme*. Cambridge: Cambridge University Press, 1987.

Hountondji, P., *African philosophy: Myth and reality*. Paris: Francois Maspero, 1995.

Ijiomah, C. (2005). African philosophy's contribution to the dialogue on reality issues. *Sankofa: Journal of the Humanities. 3. 1.* 81 – 90.

Iroegbu, P. (2004). Being as Belongingness: A Substantive Redefinition of Being. *In Ekpoma Review.* 1. 7.

Iroegbu, P., (1995). *Metaphysics: The kpim of philosophy*. Owerri: International Universities Press.

Izu O. (2009). *Beginning Metaphysics*. Enugu: Victojo Productions.

Leke Adeofe (2004). Personal Identity in African Metaphysics. In Lee M. Brown (ed.), *African Philosophy: New and Traditional Perspectives*. Oxford University Press 69--83.

Mbiti, J. (1969). *African Religions and Society*. Nairobi: Eastern Educational.

Nadel, S. F. (1952). Witchcraft in four African communities: An Essay in Comparsim. *American Anthropologist. 54.* 18-29.

Nwachukwu-Agbada, J. O. J. (2008). The Influence of Igbo Metaphysics on the Writings of Chinua Achebe. *Philosophia Africana* 11 (2):157-169.

Oduwole, E. (2010). Personhood and abortion: An Africa perspective. In M. F. Asiegbu and J. C. Chukwuokolo (Eds.). *Personhood and personal identity: A philosophical study* (pp. 97-107). Enugu: SNAAP.

Offiong, D. A. (1991). *Witchcraft, sorcery, magic and social order among the Ibibio of Nigeria*. Nigeria: Fourth Dimension.

Okpalike, C. J. B. (2012). *Witchcraft*. Nnamdi Azikiwe University, Awka, M. A Dissertation, Department of Religion and Human Relations.

Omoregbe, J. (2002). *Metaphysics without Tears*. Lagos: Joja Educational Research and Publications.

Ozumba, G. O. (2004). *African Traditional Metaphysics*. Quodlibet Journal. 6. 3. http://www.quodlibet.net/articles/ozumba-africa.shtml.

Tempels, P. (1959). *Bantu philosophy*. Paris: Presence Africaine.

TOWARDS AN AFRICAN PHILOSOPHY OF HISTORY

Introduction

A cursory glance at the engagement of history by philosophers of various extractions and epochs, reveals a couple of philosophical interpretations of history. These interpretations cluster around interrogations bordering on the meaning, structure, direction and constituent elements of history? Also arising are questions such as: "what is the meaning of history?", "what is the historical method?", "what is the relevance of the historical method to the knowledge of history?", "What is involved in our knowing, representing, and explaining history?", "what are the assumptions behind history?", "are the events of history causally connected?", "Is there a pattern in history?" and "To what extent is human history constitutive of the human present?" These have bordered the minds of philosophers over the centuries. And the philosophical thinking of these philosophers over these issues have come to constitute philosophy of history; although alternative concepts have emerged to contain the

engagement of this philosophical enterprise, concepts like metahistory, interpretative history and philosophical history (Burke 1988), the preferred nomenclature for this work is philosophy of history.

Collingwood (1946) avers that the idea of a philosophy of history was developed by Voltaire in the eighteenth century "who meant by it no more than a critical or scientific history, a type of historical thinking in which the historian made up his mind for himself instead of repeating whatever stories found in old books"(p. 1). At the end of the eighteenth century, Hegel (1959) employed the same concept in his *Philosophy of History* to speak of the development of freedom and the consciousness of freedom over the course of world history. This development is characterized by conflict and struggle, rather than smooth uninterrupted progress. This expresses itself in political developments, world-historical events like the French Revolution and in the significant actions of world-historical "heroes" such as Alexander the Great. After Hegel, the nineteenth century Logical Positivists had also employed the concept in their analysis of the general laws that governed world events. Notable among them was Comte (cited by Copleston 1975) who holds that the human mind develops through three stages: religious, metaphysical and positive stages. Karl Marx toed the same line when he maintained that civilization and human history has moved from the theological through philosophical to the scientific. According to Feuer (1959), Marx regarded religion as a bourgeois attempt to feed the masses with opium, which numbs the senses from a correct perception of reality.'

With this new development in the area of philosophy, circumstances have arisen that calls for an Africa philosophy of history. That is, a philosophy of history that raises questions about the African History. Remote effort in the history of African philosophy towards developing an African philosophy of history is seen in Mbiti (1969), who spoke of the past, the present but denied Africa the possibility of conceiving a distant future. This was challenged by Ayoade (1984) who argued that the Yoruba have linear concept of time which stretches into the future, and Izu (2010) who argued that the concept of 'African Time' as a metaphor developed by Mbiti is a preposterous, an insulting misnomer and a counter value. Blyden (1974) had also philosophically reflected on African history, which Filesi (1971) avows was a response to the question of African Identity. He traces Africa's history to the past when she contributed to western civilization, a glorious past without a contemporary consequence. Oyebola (1982) criticized Blyden on this ground. This piece has the burden of developing an African philosophy of history. It is not an attempt to retell the history of Africa as told by historians, but to philosophically examine that history. The author does not in any way intend to exhaust what could be considered an African philosophy of history, but through this work, to raise the consciousness of African philosophers to the fact of the possibility of such a philosophy of history, and thus inspire further literature in this regard.

Meaning of African Philosophy of History

In this work on African philosophy of history, the employment of the concept is not to be associated with the idea of philosophy of history in Voltaire, Hegel and Karl Mark. Philosophy as a field of human inquiry is reflective by nature. It does not reflect in a vacuum, but reflects about an object. The object of reflection could be any field of human inquiry, which itself is a collection of ideas or thoughts. What philosophy does in relation to such ideas is that it thinks about the thoughts or ideas of the area of inquiry. Since the subject of inquiry is a thought or idea, philosophy now relates to it as a second degree thought or raising second order questions about the particular area of inquiry. Chiedozie (2011) avers that:

> This branch of philosophy is a second order activity which deals with the general theories, principles, character, problems, and the fundamental presuppositions of other disciplines. It portrays philosophy as the infrastructure of the disciplines and it does this by scrutinizing the basic assumptions of other disciplines. Usually, philosophical investigation takes either a metaphysical, epistemological or ethical dimension and in doing this, the philosopher uses logic as an indispensable tool of architectonics (system of building). It is by so doing that the philosopher lets the light of wisdom touch on other disciplines to render them lucid and yield deeper comprehension. (p. 195).

When philosophy studies or reflects on history, it is not just concerned about the past and the present as the historian is, but it goes beyond that to consider even the relationship between the history and the historian who told the history (Nwodo 1964 and Unah 1996). Going beyond the questions raised by the historian, the philosopher would ask questions such as: how do historians come to know the past? The philosopher of history is not just concerned about what happened and where and when it happened; he asks questions about the certainty of the historian's knowledge. He, therefore, works with the data provided by the historian and not to duplicate the work of the historian.

The responsibility of the African philosopher in relation to history is both epistemological and metaphysical; epistemological because it raises questions regarding the certainty of knowledge of the historian- the human being who is endowed with consciousness and determines the historical reality, truth and value, and metaphysical because it raises questions about a reality that is- also about man who is the source of historical reality, truth and value. This is, however, not to create a dichotomy, both relate in an intimate way in the process of philosophical refection. There is also the question as to why this is not treated under epistemology, why do we have to create a new area of study? Special areas of philosophy emerge depends on the special problems that emerges creating special difficulties.

The idea of Africa attached to the philosophy of history only provides a context for such a philosophical reflection. The data for reflection in African philosophy of history is the

Disciplines of African Philosophy

corpus of literature referred to as African history and the African historian. By Africa, Ki-zerbo (1981) refers to the land of sunshine, of black race and mostly refers to the sub-Saharan regions of the Negroes, encompassing the territory about the city of Cartage and the Sub-Saharan Africa. It is the second largest of the Earth's seven continents, covering 30,244,000 sq km (11,677,000 sq mi), including its adjacent islands with 54 countries. It encompasses 23 percent of the world's total land area. An African philosophy of history would, therefore, be considered as an inquiry of inquiry, in the sense that while African history as an act of cognition concerns herself with the interpretation of historical data, African philosophy of history engages on in an inquiry of the inquiry of African history. While African history relies on historiography to establish what can pass as historical knowledge, African philosophy of history relies on the principles of metaphysics, epistemology and logic to delineate the claims of history or to interpret the course of African historical events.

Africa's Ingenious History: The Period of Growth

History was of great value among the people of traditional Africa- that is, before the advent of the West, and it still is. Africans understood history as a knowledge that testifies to the passing of time, helps illumine reality, vitalizes memory and brings the tidings of antiquity to the young. The value Africans placed on history is quite evident in African traditional proverbs:

a. A man who does not know where he is coming from will not know where he is going to (Igbo Proverb)
b. A stranger in town walks over hallowed graves (Nembe Proverb)
c. One who is ignorant of his origin is nonhuman (Nembe Proverb)
d. The fly who has no adviser would follow the corpse into the grave (Ikwerre Proverb)
e. The son of the soil has the python's keen eye (Ikwerre Proverb)

In these proverbs we see the understanding of history as the foundation of the future, a part of being human, and its absence a prerequisite for failure. Moving beyond the nature and relevance of history, traditional Africans also raised questions about who is qualified to tell that history. This is also evident in African proverbs:

a. More days, more wisdom (Nembe proverb)
b. What an old man sees seated, a youth cannot see standing (Ikwerre Proverb)
c. If a child lifts up his father, the wrapper will cover his eyes (Ikwerre Proverb)
d. A god whose chief priest is a child can easily get out of hand (Ikwerre Proverb)
e. However big the male lizard may be, the wall-gecko drinks the wine as the senior (Ikwerre Proverb)

While associating the telling of history with the old and experienced, Africans, however, also holds that age and experience does always guarantee wisdom and certainty of history. This is evident in proverbs such as:

a. The spirits do not kill a man for not knowing the history of his time.
b. Even a four-legged horse stumbles and falls
c. A keen ear is not as big as an umbrella
d. A large eye does not mean keen vision
e. I have killed an elephant could be true, but that I have carried it to the road must be false.

Whatever, the case, the inconsistencies associated with oral tradition, the history of Africans were told by Africans using categories Africans could understanding and without racial bias. Ancient African history reveals that Africans are the sons of Ham, one of the descendants of Noah in the book of Genesis (10). Egypt and the pyramids were built by the descendants of Ham. They, therefore, contributed to the world's civilization; they had their alphabets as is evident among the Vey people of the West Coast of Africa. Between 9000 BC and 6500 BC, in the Democratic Republic of Congo, the Ishango who lived along Lake Edward, developed their numbering system which was carved on bones. This was the earliest manifestation of the use of numbering in Africa, discovered during the excavation of the border cave in the Lebomba mountains, between South Africa and Swaziland.

Africa contributed greatly towards the development of medicine. Flinch (2001) among other scholars argues that medicine as known today began in Egypt rather than in Greece. The poverty of documents on the earliest development of medicine in Africa has been determined by the fact that those who wrote our history: Western

sociologists, anthropologists, missionaries had great contempt for African culture and so transmitted only what they considered necessary or reasonable. And also, Africa had been through a lot of negative experiences, the slave trade and colonialism particularly, which politically, socially, culturally, economically disrupted the African traditional structures.

Woods (1988) asserts that the ancient African society made great contributions to astronomy which modern science still relies on. As far back as 2,150 BC, about 4,000 years ago, ancient Egypt charted the movement of the sun and the circles of the moon. It was in Egypt that Thales, the Greek sage received his education; and here he was trained in astronomy. They divided the year into 12, and developed a yearly calendar system that has 365 days. The initial purpose for this development in ancient Africa was to know when to plant their crops. As far back as this period, clocks were already made. As far back as 300 BC, Lynch and Robbins (1983) observe that Kenya already had a remarkable accurate calendar that was based on astronomy.

Brooks (1971) observes that across the entirety of ancient Africa, there were advancements in metallurgy and tool making. According to Shore (1983), developments in metallurgy in places like Tanzania, Rwanda and Uganda between 1,500 and 2,000 years ago were far ahead that of Europe and sent shocking waves to the Europeans when they came to Africa. In fact, Peter Schmidt and Donald Avery of the Brown University, USA, historical anthropologist and engineer respectively, who worked together among the Haya

people of Lake Victoria, argued that Africans who lived in Lake Victoria, in Tanzania had produced carbon steel as far back as 2,000 years ago. They observed that the furnaces of ancient Tanzania could go as far as 1,800 degree centigrade – 200 to 400 degree centigrade warmer than those obtainable in Rome. With these developments, it can be said that Africa was not just a footnote to ancient history; she contributed significantly to virtually every dimension of it.

The Defilement of Africa's History: The Period of Decline

The history of Africa from the period of the slave trade through the times of colonialism reveals systematic and ruthless attempts to deny African people the fundamental human right of self-determination and self-identity. Having classified the Negro as backward, inhuman, primitive, illogical, emotional and capricious, and by no way equal to the white race, the West had no qualms exploiting Africans to their benefit with the dawn of the Industrial Revolution in the Western hemisphere. The European expanding empires at this time lacked manpower to work on new plantations that produced sugar cane for Europe, and other products such as coffee, cocoa, rice, indigo, tobacco, and cotton. Contrary to the native Americans, Africans were excellent workers: they often had experience of agriculture and keeping cattle, they were used to a tropical climate, resistant to tropical diseases, and so the Atlantic slave trade became an integral part of an international trading system which was then guarded by international laws.

This period of carnage, as reported by Kanu (2008) lasted for about five hundred years during which an estimate of 12 million viable Africans were enslaved from their home lands to locations around the Atlantic. The vast majority went to Brazil, the Caribbean, and other Spanish-speaking regions of South America and Central America. According to Gimba (2006), smaller numbers were taken to Atlantic islands, continental Europe, and English-speaking areas of the North American mainland. For about 200 years Portugal dominated in this trade (they are said to have begun slave trade at about 1440), and were not long after joined by the Spanish, French, Dutch, after 1560 the English also joined in the trade and merchants from Liverpool were not exempted. Kanu (2008) avows that it is estimated that during the five centuries of the trans-Atlantic slave trade, Portugal was responsible for transporting over 4.5 million Africans, which is about 40% of the total. During the 18th century however, when the slave trade accounted for the transport of a staggering 6 million Africans, Britain was the worst transgressor - responsible for almost 2.5 million. This was a trade in which human nature was depraved and fellow creatures manipulated in infinite variables.

Since Africans were regarded as sub-humans, Njoku (2002) states that colonialism became a gospel of redemption and elevation of the black man to some human status. By the middle of the 19th C, Hodder (1976), observes that European explorers began to make significant advances into tropical Africa. Missionaries also took an increasing part in extending European interests as all explorations and evangelism led to trade. When the west realized that profitable trade depended

Disciplines of African Philosophy

on administrative intervention and control in the hinterlands, Kanu (2012) posits that Africa soon became a field for the conflicting ambitions of the major European colonial powers. By the early 1880's these conflicting ambitions were beginning to be expressed territorially. Sections of the coast were being claimed by traders and administrators of one or other of the European powers. Missionary, trading, military and administrative activities were beginning to expand. In the contention of Hodder (1978), the stage was now set for the European scramble for Africa, finally to be set in motion by the 1884-5 Conference and Treaty of Berlin.

With these developments, the African lost his dignity among the community of nations. By the time Charles Darwin produced his theory on the "origin of species by natural selection" an enduring and virulent form of racism against Africa was inevitable. By the 19th century, the dignity of the African was trampled. Masolo (1994) observes that this was intensified through the writings of western scholars. Linnaeus (1758), stated that all creatures were arranged by God in a great chain of hierarchy with human beings at the head. However, among human beings, he wrote that *Africans* were cunning, slow, negligent and ruled by caprice. Gobineau (1915), also developed a biased anthropology. He placed human beings on a hierarchy with Africa at the bottom. Hume (cited by Chukwudi 1998) wrote, "I am apt to suspect that the Negroes to be naturally inferior to the whites. There scarcely ever was a civilized nation of that complexion, nor even an individual eminent in action or speculation" (p. 214). Hegel (1956), also had a biased perception of the Negro. He wrote,

> In Negro life the characteristic point is the fact that consciousness had not yet attained to the realisation of any substantial existence.... Thus distinction between himself as an individual and the universality of his essential being, the African in the uniform, undeveloped oneness of his existence has not yet attained. (p. 93).

He thus posits that the Negro is yet to go beyond his instinctual behaviour to identify a being outside of himself. Levy-Bruhl (cited by Njoku 1993), went further to write:

> The Negro is still at the rude dawn of faith-fetishism and has barely advanced in idolatry.... he has never grasped the idea of a personal deity, a duty in life, a moral code, or a shame of lying. He rarely believes in a future state of reward and punishment, which whether true or not are infallible indices of human progress". (p. 199).

With these perspectives, negative literature spread like wildfire about Africa. Scholars like Blatch (2013) who argued in favour of the achievements of science and technology in ancient Africa, observed that the contributions of ancient Africa to science and technology is not referred to in the writings of European historians. While reference is made to the Greeks, Romans and other Western civilizations, no reference is made of the contributions of Africa. It is in this regard that Sertima (1983) avers that "the nerve of the world has been deadened for centuries to the vibration of African genius" (p. 7). Although there are times reference is made to Egypt, the history of Africa beyond ancient Egypt is hardly

publicized. The result is that many are not aware of this culture of achievements, the sophistications and impressive inventions that were obtainable in ancient Sub-Saharan Africa.

Reconstruction of African History: The Period of Change Over

The model of the history of Africa employed in this work is that of growth, decline and changeover. The beginning of Africa was characterized by growth as can be seen in the contributions which she made to civilization. This was followed by a period of decline, initiated by the encounter of Africa with the Western world; this period was characterized by the slave trade, colonialism and racism. This work argues that Africa's history has come to a period of changeover to another age. During the period of growth, Africa was in control of her history and the recording of that history. After the period of growth, the history of Africa became a toy in the hands of the west, who determined it and also wrote it down according to their wishes. The period of changeover is a time, the present time, when Africans must take their destinies into their hands.

Not minding that the personality of the African that has been ravaged by the slave trade, colonialism and racism, there is optimism that change is possible through the education of the Negro of his capabilities and contribution to ancient civilization. This education must begin from letting the African know who he is. Socrates' fundamental dictum for growth: *Gnothi seauton,* "Man know thyself". If

the African understands where he is coming from, it would help him know where he is going to. Only then would the African, like a sleeping giant wake up from his slumber and harness his power for his own good and also contribute to the global world (Ozimiro, 1978).

The kind of education that is called for here must be relevant to the context of the African. Blyden (1967) avers that, "Lord Bacon says that 'reading makes a full man'; but the indiscriminate reading by the Negro of European literature has made him, in many instances, too full, or has rather destroyed his balance" (p. 81). Azikiwe (1961) had this idea, when he called for "a state of society where the mind is brought into harmony with matter... a psychological conception deeply rooted in a material environment" (p. 15); He further argued that "The usefulness of any concept, idea or theory, lies in its implications for the practical solutions to the problems of society. In this sense, pragmatism requires that man's efforts and intelligence should be geared towards the liberation of man and the satisfaction of his needs in society" (p. 277); and so our education should be aimed at providing means of livelihood for Africans.

Education should be able to generate a proud independent and free citizenry which relies upon itself; it must ensure that the educated know themselves to be an integral part of the nation and recognize the responsibility to give greater service. Awolowo (1968) had called for an education that is wholistic for Africa. This must include the mind, the body and the brain. This was the kind of education that brought about a phenomenal rise from underdevelopment

to development in states such as the USA, Japan and USSR were due to education. Education that focuses on acquisition of certificates and laurels is not the emphasis at this point, but one that helps the educated with the ability to reflect on his/her actions, thought and deeds. If a man's body is developed and his brain and mind are not developed he stands to be exploited. On the other hand, if a man's mind is developed and the brain and body are not developed he becomes a religious fanatic, pessimistic and fatalistic. Those who engage in terrorism for religious purposes fall within this category.

Economic self-sufficiency is also an ultimate means for the redemption of Africa. No matter how educated Africans may be, as long as they lack economic self-sufficiency, they will fail to realize a stable society.

The slave trade and colonization of Africa created a situation of the 'crisis of self-confidence' in the African, which has opened apertures for a lasting barrier to growth and innovation. Zik argues that there is no specific proof to sustain the idea of superiority or inferiority of any race, and for the African to cultivate an inferiority complex is to sign the death warrant of Africa's future. To decolonize the African, Nkrumah developed the idea of conscientism. According to Nkrumah (1964), African history through the centuries has accumulated much of confused teachings and orientations from external influences: colonial imperialists, Islamic and Euro-Christian elements, thus producing equally a confusing and conflicting vision. The situation has been worsened by the deceptive presentation of African

history as a story of Western adventure. To undertake fully the venture of the unification and liberation of Africa, a reforming, revolutionalizing and inspiring philosophical system is indispensable. He calls this system *Philosophical Conscientism*. It would serve as a "body of connected thought which will determine the general nature of our action in unifying the society which we have inherited, this unification to take account, at all times, of the elevated ideals underlying the traditional African society" (p. 78). According to Nwoko (1988), this would further equip the African to sift and blend appropriate values for the major elements of African history to form or fit the African personality. To help resolve the crisis of conscience already created by the contact between Africa and the West, Nkrumah (1964) writes that:

> Our philosophy must find its weapons in the environment and living conditions of the African people. It is from those conditions that the intellectual content of our philosophy must be created. The emancipation of the African continent is the emancipation of man. This requires two aims: first, the restitution of the egalitarianism of the human society, and, second, the logistic mobilization of all our resources towards the attainment of that restitution. (p. 78).

He believes that this would help bring about the total liberation of the African person.

Addendum

Human and cultural contacts and interactions are part of the cosmic dimensions of our being. The problem of colonialism is not that other races or peoples or cultures met our people and culture, but the manner, the violence, the submission or exploitation which ensues.

i) Africans must today recognize certain inevitabilities: our historical encounter with the West, whether for good or for worse, is irreversible.

The world to which colonialism or imperialism has brought us is not the world our ancestors lived in: but a world which has become a global village. So we cannot, in the name of authenticity, revive structures and practices which no longer have any relevance.

The best in a people and for the people are not necessarily in the past; the contrary is the fallacy of romanticism and cultural Puritanism. Even our ancestors will shudder that, at times we try to give an air of finality and undue reverence to their practices without a necessary critique; after all, their cultures and practices and their development were relative to the level of knowledge available to them. This is not to relegate our past for merely historical interest, but to have a critical attitude to it. Surely, "We need our past, we need our present for the future. We need a meaningful and relevant past which is a past which can meet with the challenges of the present and is able to open up a vista for survival and progress for the future. The past must be modern and contemporary to be relevant and liveable, that is a past which sheds off its archaic

toga, a past which favourably responds to contemporary critique, the basis of its legitimacy and acceptability".[47]

ii) It will be a great service to our culture and to the African man if, due to anger, or in the name of cultural integrity, we do not shut ourselves to the important values and achievements of modern science and technology. We will only do this to our peril. African cultures were subdued due to superior technology of the white man, in the world of economic globalization and competition and other conflicts; we cannot afford not to appropriate the opportunities which modern technology can afford. And in all these, we have to be selective in deciding what to adopt, and what not to, without forgetting other attendant consequences of human actions. Ratzinger was right, though some exaggerations, when he said:

> Whoever looks more closely can easily see that there can be no simple return to the past. For it is not only the case that the convergence of mankind towards a right community with a common life and destiny is unstoppable because such an inclination is grounded in man's essence but also because the diffusion of technological civilization is irrevocable. It is a romantic dream to want to preserve pre-technological Islands in the sea of humanity. You cannot enclose men and cultures in a kind of spiritual nature reserve.... For in reality modern civilization is not a mere multiplication of knowledge and know how. It deeply encroaches upon the basic understanding of man, the world and God[48].

Modern civilization has changed standards of behaviour. It has altered the interpretation of the world at its base.

History offers us lesson in this respect namely the experience of China and Japan. For example in 1956, Moa Tse Tung, talking to the music workers said: "The things which you study are useful, but you should master both western and Chinese things, do your utmost to master Chinese things, do your utmost to study and develop them with the aim of creating our own Chinese things with characteristic natural form and style. If you grasp this basic policy, your world will have a quiet future."[49]

One thing striking from Moa's statement is that a country must have a culture and technology and educational policies, which will help it capture the enemy's weapons and discover its secrets, its techniques and use to one's proper benefits. So cultural development or empowerment requires a political will and policy to that effect.

References

Alagoa, J. E. (2015). *An African philosophy of history in the oral tradition*. Retrieved 26/7/16 from www.**africas**peaks.com/reasoning/index.php?topic=1213.0;wap2.

Ayoade, A. A. J. (1984). Time in Yoruba thought. In R. A. Wright (Ed.). *African philosophy* (pp.32-44). Lonham: UPA

Awolowo, O. (1968). The People's Republic. Ibadan: Oxford University Press.

Azikiwe, N. (1961). *Renascent Africa*. New York: Negro University Press.

Blatch, S. (2013). *Great achievements in science and technology in ancient Africa. ASBMB Today February.* 1-13.

Blyden, E. (1974). The Negro in ancient history. In M. S. Henry (Ed.). *The people of Africa: A series of papers on their character* (pp. 6-21). Ibadan: Ibadan University Press.

Brooks, L. (1971). *African achievements: Leaders, civilizations and cultures of ancient Africa*. USA: Paperback.

Burke, P. (1988). Metahistory. In Bullock, A; Stallybrass, O and Trombley, S. (Eds.). *Fontana Dictionary of Modern Thought.* London: Fontana Press.

Chukwudi, E. E. (1998). Modern western philosophy and Africa colonialism. In E. E. Chukwudi. *African philosophy: An anthology* (pp.200-215). Oxford: Blackwell.

Collingwood, R. G. (1946). The idea of history. Oxford: Oxford University Press.

Copleston, F. (1975). *A history of philosophy*. London: Search.

Feuer, L. (1959). Writings of Karl Marx and Engels. New York: Doubleday.

Filesi, T. (1971). *Movimenti di emancipazione colonial a nascita dei nuovi stati in Africa*. Milano.

Flinch, C. (2000). *African background of medical science*. Retrieved 13th January 2015 from http://raceandhistory.com/selfnews/viewnews.cgid.shtml.

Gimba, T. (2007). *Lecture note on traditional African societies*. Jos: St Augustine's Major Seminary

Gobineau, A. (1915). *The inequality of human race*. London: William Heinemann.

Hegel, G. W. F. (1956). *The philosophy of history.* New York: Dover.

Hegel, G. W. F., *The philosophy of history.* New York: Dover, 1956.

Hodder, B. W. (1978). *Africa today: A short introduction to African affairs.* London: Methuen.

Izu, M. O. (2010). The problematic of African time. *Uche: Journal of the Department of Philosophy, University of Nigeria, Nsukka. 16.* 19-38.

Kanu, I. A. (2008). Africa's experience of the slave trade: The classical position of the Church. *The Augustinian Viewpoint Magazine. 6. 7.* 23-30.

Kanu, I. A. (2012). The colonial legacy: The hidden history of Africa's present crisis. *Afrrev Ijah: An International Journal of Arts and Humanities, 1. 1.* 123-131.

Linnaeus, C. (1758). *System of nature.* Stockholm: Laurentius Salvius.

Lynch, B. M. and Robbins, L. H. (1978). Namoratunga: The First Archeoastronomical evidence in Sub-Saharan Africa. *Science. 4343.* 766-768.

Masolo, D. A. (1994). *African philosophy in Search of Identity.* Indianapolis: Indiana University Press.

Mbiti, J. S. (1969). *African religions and philosophy.* Kenya: Sunlitho.

Njoku, F. O. C. (1993). A Phenomenological critique of the Igbo God-Talk. *Encounter: A Journal of African Life and Religion. 2.* 70-91.

Njoku, F. O. C. (2002). *Essays in African philosophy, thought and theology.* Owerri: Claretian Institute of Philosophy.

Nkrumah, K. (1964). *Conscientism.* London: Heinemann.

Nwodo, C. (1989). 'A critique of Copleston's objection to philosophy of history'. *Nigerian Journal of Philosophy.* 9. 1-2.

Nwoko, M. (2006). *Baisc world political theories.* F. O. C Njoku (ed.). Enugu: Snaap Press.

Nzimiro, I. (1978). Zikism and social thought in the Nigerian Pre-independence Period, 1944-1950. Onigu Otite (Ed.). *Themes in African Social and Political Thought* (pp. 281-301). Malta: Fourth Dimension Publishers.

Oyebola, A. (1982). *Black man's dilemma.* Ibadan: Board Publications.

Sertima, I. V. (1983). The lost sciences of Africa. In I. V. Sertima (Ed.). *Blacks in science: Ancient and modern* (pp. 7-26). New Brunswick: Transaction Books.

Shore, D. (1983). Steel-making in ancient Africa. *Blacks in science: Ancient and modern* (pp. 157-162). New Brunswick: Transaction Books.

Unah, J. (1996). *Metaphysics, phenomenology and African philosophy.* Ibadan: Hope.

TOWARDS AN AFRICAN COSMOLOGY

Introduction

In an attempt to understand the meaning of 'African Cosmology', it would be worthwhile to first explore the concept 'cosmology'. By etymology, it is from the Greek words: *cosmos* and *Logos*, meaning 'universe' and 'science' respectively. Put together, it is the 'science of the universe'. Thus, *cosmos* and universe will be used interchangeably, and by universe it is meant worldview. For a further and profound enquiry as to the meaning of worldview, there is a copious pool of literature available in this regard. One needs to glance at the works of eminent scholars like Wambutda (1986), Ejizu (1986), Achebe (1958), Onuoha (1987), Metuh (1991) and Madu (2004). Very significant to their analysis, is an underlying principle that speaks of cosmologies as basically religious, which gives a sense of purpose and direction to the lives of people and enables them to act purposefully and exercise a measure of control over their environment. It is in this regard that Metuh (1991) maintains that cosmology answers fundamental questions

about the place and relationship of man with the universe. This cannot be done outside the ambience of supernatural power or powers and thus religion.

What then is African cosmology? It is simply the way Africans perceive, conceive and contemplate their universe; the lens through which they see reality, which affects their value systems and attitudinal orientations; it is the African's search for the meaning of life, and an unconscious but natural tendency to arrive at a unifying base that constitutes a frame of meaning. This cosmology is the underlying thought link that holds together the African value system, philosophy of life, social conduct, morality, folklores, myths, rites, rituals, norms, rules, ideas, cognitive mappings and theologies.

The idea of African worldview must be understood in a general sense and in a restricted sense, because what we call African worldview is not one shared by all Africans but rather some characteristic features of the of African worldviews.

According to Madu (2004), an investigation into the nature of African cosmology would beg a couple of fundamental questions that determine its course:
i. What is the nature of the African universe?
ii. Who is the maker and sustainer of the African universe?
iii. What is the nature of the beings in the African universe and the interactional network in the African cosmic order?

Disciplines of African Philosophy

The Structure of the African Universe

The African universe has the physical and the spiritual dimensions (Edeh 1983, Abanuka, 1994, Ijiomah 2005, Unah 2009). At the spirit realm, God represents the Chief Being, and seats at the apex of power. In the physical world, human beigs dominate, occupying the central position in the scheme of God's creation. In the contention of Onunwa (1994), the African cosmos is like an isosceles triangle with God (the Supreme Being) at the apex. The ancestors are at the base of the triangle, with the human being at the centre. The primacy of the human being in the African universe is due to the central place he/she occupies within the universe. The triangular imagery suggests that human beings form a "microcosm" on which converges the innumerable forces that inhabit the other arms of the universe.

Ijiomah (2005) avers that the African universe consists of three levels: they are the sky, the earth and the underworld:

> The sky is where God *Chukwu* or *Chineke* and angels reside; the earth is where man, animals, natural resources, some devils and some physical observable realities abide; and the underworld where the ancestors and some bad spirits live (p. 84).

Ekwealor (1990), corroborates Ijiomah's view by describing the African universe as consisting of three spheres, namely: *Elu-Igwe* or sky, *Alammadu* or the world of the living and *Alammuo* or the land of the spirits.

The African worldview, therefore, consists of both spiritual and physical realms, which despite their separate existence interact. Ekwealor (1990) avers that "It is important to note that although the Igbo universe is divided into these three broad structures, there is the possibility of certain elements to move from one structure to another to commune with other elements" (p. 30). In this interaction, man communes with God, the divinities, the ancestors and vice versa. The African world is, thus, an interactive universe.

God in the African Cosmos

God in the African universe, according to Quarcoopome (1987), from his names and attributes, is a reality and not an abstract concept. Idowu (1973) avers that he is a personal being with whom one can enter into communion and communication. He is approachable in all occasions of life. In societies where there is hierarchy of power, from the king to the chiefs and common people, the idea of God is also presented within the frame of a hierarchy. This is evident in the Yoruba, Benin and Akan concepts of God. However, where such hierarchies are not well developed, the idea of God is presented in plain terms, as among the Nupe and Tiv. Among some cultures, he is conceived as masculine, as among the Yoruba, Mende and Akan; in some others as feminine, as among the Ewe; in some others, he is conceived as both male and female, as among the Gas.

The Yoruba call him Olodumare or Edumare (The King of heaven)

The Igbo call him Chukwu or Osebuluwa (Great God or sustainer of the universe)

The Edo call him Osanobua or Osanobwa (Creator and sustainer of the universe)

The Nupe call him Soko (The supreme deity that resides in heaven)

The Ijo call him Temearau (The creatress of all things –feminine term-)

The Tiv call him Aondo (The power above that creates and rules all things)

The Ibibio refer to him as Obasi Ibom (The God who lives above the earth)

The Akan call him Odomankoma and Nyame (full of mercy and the God of fullness respectively)

The Mende of Sierra Leone call him Ngewo (The eternal one who rules from above)

The Kono of Sierra Leone call him Meketa (The Immortal or eternal)

From the meanings of these names of God from different African cultural backgrounds, his attributes already begin to emerge.

The Attributes of God

There are differences in the concept of God among Africans. Oguejiofor (2010) observes that the differences are based on the epiphenomenal of the global condition of life of the people under consideration. These differences notwithstanding, Idowu (1973) avers that there are unifying attributes of the African Ultimate Reality. These attributes according to Awolalu and Dopamu (1979) are words or phrases that

speak of the traits, properties, qualities or characteristics of God and what is believed to be his role in relation to the world and human beings. These attributes bring down the divine from the high mountain of the metaphysical and abstract to the level ground of the real and concrete.

i. **God is Real and Active:** For instance among the Igbo, he is called: *Chineke* (the God who creates), *Chukwu* (the great God), *Osebuluwa* (the sustainer of the universe), *Ekekereuwa* (he who created the world), *Chi-oke* (God that apportions lots), *Nna-di-Ebube* (the awe-inspiring father), *Odogwu-nagha* (victorious warrior), *Ome Mgbeogharike* (actor in times of difficulty). From these names, God is real and active. Thus, if he fails to respond as expected, the Igbo would ask "*Chukwu I no nura?*" (God are you asleep?)

ii. **God is Unique:** By unique, it is meant that he is different from other creatures. In the African universe, God occupies a unique place, high and above all other creatures as the Creator. He is transcendent, sovereign and possesses absolute power.

iii. **God is the absolute controller of the universe:** The African God is not a withdrawn God; he has full control of the universe. The Igbo would refer to him as *Osebuluwa* (the sustainer of the universe). He did not just create the world but actively sustains it. All other creatures are in being for the reason that he is also in existence. He is neither a Remote God *(Deus Remotus)* nor a Withdrawn God (*Deus Otiosus*). He is both transcendent and immanent.

Disciplines of African Philosophy

iv. **God is One:** Among the Igbo, there is only one God called *Chukwu,* even though the nomenclature is contested. He is regarded as the God and creator of the whole universe.

v. **God is Creator:** Africans have the belief that God either created the world or delegated some divinities to carry out some assignments as regards the creation of the world. Thus, Oduwole (2010) and Idowu (1962) aver that the body is the creation of *Orisha nla* (Arch-divinity). He was assigned by *Olodumare* (the Supreme Being) to mould the body of human beings. It is only the Supreme Being that puts the spirit into the body to give it life. However, if a divinity is delegated, it does not take the place of God as creator.

vi. **God is King:** Most African traditional societies speak of God as King. As king, God is the sovereign controller of the universe. Among the Mende, he is "The Chief"; among the Yoruba, he is *Oba Orun* "The King in heaven"; among the Igbo he is *Eze Enuigwe* "The King of Heaven".

vii. **God is Omnipotent:** Since there is no limit to the being of God, and every being acts according to its nature, it would imply that His power is without limit. He does everything possible, even the ones we sometimes consider impossible. A God without this attribute fails the first test of deity. Among the Akan of Ghana he is Otumfoo (The Mighty or Powerful One); the Yoruba concept of God as *Olodumare* and the Igbo concept of God as *Chukwu* also speak of the omnipotence of God.

viii. **God is Eternal:** Eternity is the total simultaneous and perfect possession of life without limits. This implies

that God has no beginning or end. He made us abides forever and is always the self-same and His years do not fail. Indeed, the very substance of God is eternity. Thus, the Yoruba refer to him as *Oyigiyi Ota Aiku* (The mighty immovable, hard, ancient, durable rock that never dies).

ix. **God as Judge:** The African believes that all his/her actions will be judged, rewarded or punished. God is the impartial judge who will either reward or punish him/her for his/her actions, both private and public.

Divinities in the African Universe

As already indicated, in the African world, there is only one God, who is high and is expected to be reached through intermediaries. These intermediaries are called divinities. Most Africans believe that they emanate from God; as such, it is incorrect to say that they were created by him, but correct to speak of them as offsprings of the Supreme Being. It is, therefore, not surprising that the *Abosom* of Ghana, *Orisa-nla* of the Yoruba, *Olokun* of the Edo are referred to as sons of the Supreme Being.

Divinities are responsible to God for whatever act they perform in their relationship with human beings. Their function is to ensure that God is not bordered by petty problems from the earth; they are not an end in themselves but a means to an end, and everything they do is dependent upon God's approval; this does not in any way change the fact that they are a powerful set of spiritual beings. They are functionaries in the theocratic governance of God, sometimes referred to as his messengers and at other times

Disciplines of African Philosophy

as his sons. Awolalu and Dopamu (1978) refer to them as the executive heads of various divine departments in the Supreme Being's monarchical government.

Each of these divinities has a name, usually describing its function: as we have *Ala* among the Igbo meaning earth, therefore, the earth-goddess. *Olokun* in Yoruba, *okun* meaning ocean, thus, the god of the sea. Arinze (1970), speaking on divinities from the Igbo perspective, avows that:

God is the Supreme Spirit, the creator of everything. No one equals him in power. He knows everything. He is altogether a good and merciful God and does harm to no one. He sends rain and especially children, and it is from him that each individual derives his personal 'chi'. But this supreme spirit has made many inferior spirits who are nearer to man and through whom man normally offers his worship to Him. (p. 10).

The difference between these divinities and the Supreme Being is very obvious. They are inferior spirits, while God is a superior spirit. They vary in number from place to place, however with more among the Yoruba where there are about 1700 divinities. No matter their number, they are a group headed by the arch-divinity as we see in the case of *Orisa-nla* among the Yoruba divinities. It is an arch-divinity and the head of all divinities among the Yoruba.

The Categorization of Divinities

Awolalu and Dopamu (1978) categorize divinities into three. They are:

1. **Primordial Divinities:**
 These are divinities that dwell in the heavens. They were with the Supreme Being during the creation of the universe. Like the creator of the universe, their origin is not known. An example of this kind of divinity is *Orisha nla*.

2. **Deified Ancestors:**
 The deified ancestors are human beings that lived extraordinary or mysterious lives and later became divinities after their death. This is very common among the Greeks, Egyptians and the Romans. Among the Yoruba, we have Sango who was a former powerful king of Oyo. With the deification of the ancestor, he/she ceases to be an ancestor and takes up the qualities of a divinity.

3. **Personified Natural Forces and Phenomena:**
 The African universe is made up of myriad of spirits. These spirits have their abode on mountains, hills, rivers, seas, oceans, trees, roads, markets, caves, brooks, lakes, forests, etc. Their abode also determines the place where they are worshipped, and also the residence of the Priest of the deity. It is common in Africa to hear of spirits causing accidents on bridges, these are spirits that dwell in water, often called mummy water. Some spirits dwell

in trees and cause road accidents, often interpreted as sacrifice to the divinity in question. There are sociological factors that affect the habitats of these divinities. For instance, people in the riverine areas venerate water spirits. People who live in places where there is forest venerate the forest spirits. People in mountainous areas venerate spirits that dwell on the mountain.

Divinities among the Yoruba of Western Nigeria

1. **Orisa-nla:** It is also known as *Obatala* (which means king of whiteness or the Lord of white cloths), the creator divinity and arch-divinity. The body is the creation of *Orisha nla*. He was assigned by *Olodumare* (the Supreme Being) to mould the body of human beings. He also created solid earth and equipped it. While he creates the body, the Supreme Being puts the soul in the body. It lies within his department to make a human being beautiful or ugly. Its shrine must be clean, everything used is white in colour, and the water used at *Orisha nla's* shrine must be kept clean. Water from its shrine is fetched very early in the morning and given to pregnant women so that the children they carry in their womb may be properly moulded. Those who are physically challenged are healed with this water. It is in fact regarded as the god of purity or the holiness of God and its worshippers are expected to be pure as well.

2. **Orunmila or Ifa:** It is the divinity of wisdom, prognostication and foreknowledge, and in fact the oracle divinity of Yoruba land. After God had made the human soul and sealed its destiny, it is believed that *Orunmila* was present and knows its secrets, that is why he is always consulted before undertaking an action, say marriage, war or a journey, to give information about the past, present or future of man. His priest is called *Babalawo*, which means 'the father who has the secret'.

3. **Ogun:** It refers to the god of iron and war. As the god of iron, it appropriately is the patron god of blacksmiths, hunters and warriors and is symbolized by Iron. Like the Igbo *Amadioha*, he is the messenger of God's wrath. Because of the fear it evokes, people go to it to seal their covenants, as fear of him brings about the fulfilment of your own part of the covenant. He is not just the messenger of God's wrath and judgement, he also grants success to warriors and hunters. Even in our time, travellers turn to him for protection from accidents.

4. **Esu:** As the Igbo *Ekwensu* was misunderstood by missionaries and new converts to Christianity as the Biblical devil, *Esu* has also been misunderstood as the Christian devil. It is the god of mischief and could make things difficult for people. He is always present as an inspector in matters of rituals and conduct, among divinities and human beings.

Disciplines of African Philosophy

Having inspected a ritual, his recommendation determines if the Supreme Being will accept the sacrifice or not; he stands before the Supreme Being accusing both human beings and divinities, especially when it is not properly fed with sacrifices; however, when he is given his due, he can be benevolent in terms of protection, however, could e unpredictable. He is feared by both human beings and divinities. Awolalu and Dopamu (1978) illustrate this fear thus: "Once Sango, the thunder divinity of Yorubaland, boasted that there was no divinity he could not subdue. But Esu asked him promptly whether he included him, and Sango immediately replied apologetically that he could not have been included" (p. 83).

5. **Sango:** Just as the Igbo *Amadioha* is the god of thunder and lightning, Sango is the Yoruba god of thunder and lightning, with his presence manifested in thunderbolts and lightning. He was one of the kings of Oyo kingdom, an Alafin of Oyo. And his reign was tyrannical, and he could spit out fire during fits of anger. When he was deposed as king, he committed suicide by hanging himself. He is highly dreaded, and punishes offenders through thunderbolts. Thus periods of lightning and thunderbolts are terrifying moments for offenders. When it strikes a human being, the person is not mourned; when he strikes a building, no body sleeps there until a special sacrifice is done.

6. **Sopono:** He is the god of small pox, which is seen as a manifestation of the wrath of God on offenders. Like *Songo*, he is also dreaded. When it attacks liars or other offenders and it leads to death, they are not to be mourned.

7. **Osun:** She is the wife of *Songo* and the goddess of the river of Osun. She is a benevolent divinity, evident in her name, 'the goddess of children'. She specializes in restoring the fruitfulness of barren men and women. Since streams and rivers are her abode, gifts to her are thrown into the river or stream. Although she specializes in child giving, she could also be approached to solve other problems.

8. **Oya:** *Oya* is a female divinity, referred to as the goddess of the River Niger. If Sango was an Alafin of Oyo, *Oya* is believed to be his first wife, who wept after his death, weeping so severely that her tears formed the River Niger. She could neutralize the anger of *Sango*. Whenever he spits fire during his fits of anger, *Oya* neutralizes his anger with rain. Like Osun, her abode are rivers and streams.

9. **Buruku:** According to the tradition of the Yoruba, *Buruku* is a god brought from Sabe, in Dahomey. It is referred to as *Buruku Omolu*, meaning "the child of the Supreme Being". It is believed that it is responsible for deaths, illnesses, catastrophes and other human miseries; however, he is also capable of blessing and protecting worshippers. Worshippers

must placate its anger through sacrifices. During worship, small children, pregnant women and menstruating women are a taboo to *Buruku*.

10. **Ayelala:** Like Sango, it is a deified ancestor. According to Awolalu and Dopamu (1978), "She was originally a slave woman brought from Ekitiland to Kisoso in Okitipupa of Ondo State, and offered as a substitutionary sacrifice for peace between Ileja and Ijo who were at war with each other" (p. 90). Keko from Ileja slept with the wife of chief Temetan, and ran away to Ijo to avoid being killed. During the settlement of the case, it was agreed that if Keko must live, a substitute is required to die for him. It was at this time that Ayelala, the slave woman was offered as a substitutionary sacrifice. Through her death she brought peace between the peoples of Ileja and Ijo, and so was worshipped by both Ijo and Ileja.

Divinities among the Igbo of Eastern Nigeria

i. *Anyanwu* **(Sun):** It is the son of *Chineke*, and sacrifices that are made to *Chukwu* are made through *Anyawu,* because of the special and close association of the sun with the Supreme Being.

ii. *Amadioha* **or** *Igwe* **(Sky):** It is also the son of *Chineke*, and sometimes referred to as the husband of *Ala*. Just as a husband fertilizes his wife so does *Amadioha* fertilize his wife *Ala* through rainfall. It expresses its power in thunderbolts and lightening.

He is an agent of *Chukwu* against undetected crimes. Through his intercession, *Chukwu* nourishes the green vegetation of the earth, sees to the health of the living, lightens up the world and gathers evidences as well as bears witness for good deeds and against evil deeds of people. It ensures that the natural order as set by *Chukwu* is not upset. Its principle is simple, 'eye goes for an eye and a tooth goes for a tooth'. Whatever one sows, one will reap".

iii. ***Ahiajoku* (god of agriculture):** Farmers offer sacrifices to this deity for a bountiful harvest.

iv. ***Ala* (Earth goddess):** It is the most important deity in Igbo public and private cults. She is the sole daughter of *Chukwu* and is believed to have made the ground and the vegetable kingdom. The earth goddess has the function of exposing those who secretly commit evil and the evils they commit. Therefore, the Igbo say:

- *Ani tukwa gi* – may the earth expose you.
- *Ani bokwa gi ji n'aja* – may the earth goddess render you miserable and expose your shame.
- *Ani jukwa gi-* may the earth reject your corpse.

In Igbo land, the earth is holy, and from it God produces all living things, including human beings. It is also through this earth that human beings join their ancestors. When a person, therefore, commits a crime, he/she is said to have "*Meruo Ala*" (defiled the earth). If such a person dies without having "*Mejuo Ala*" (pacified the earth), the earth goddess whose function is to expose people's atrocities will reject the corpse of such a person. When the

person is buried, the earth goddess throws up the corpse out of the belly of the earth. In this case, the bereaved are left with the option of cremation. The implication being that the soul of the person is destroyed and will never reincarnate. For such a soul, the Igbo would say: "enu erughi ya aka, ani erughi ya aka", meaning that he/she has no share in the sky or earth. They end up as wicked spirits.

v. ***Chi-omumu*** **– (the goddess of children):** It is her responsibility to ensure the continuity of human and animal life. Those who seek children pray to *Chukwu* through her.

vi. ***Nmuo Mmiri*** **or** ***Nne Mmiri*** **(sea goddess):** She is the sustainer of sea life, the bringer of hope, provider of help and protection, the bringer of gifts and exotic things. Indeed. She is said to hold the key to the gate that leads to the world of solutions. Whenever the Igbo pray they do not forget to add *ka uzo anyi buru uzo mmiri,* which means, "may our journey follow the path of the stream". It is she who guides people to exotic lands, and chooses to permit human beings to travel and reach their destinations on top of the sea.

vii. ***Ekwensu*** **(god of warriors):** Missionaries have wrongly identified *Ekwensu* with the Christian devil. According to Metuh (1991), *Ekwensu* is the spirit of violence and patron of warriors and not the Christian devil. Isichie (1969), records that among the Igbo of Asaba, there was a festival called *Ekwensu* festival, and it constituted their major annual feast, during which they displayed their military prowess.

viii. ***Agwu* (the god of divination and healing):** It is the chief messenger of the Almighty God. Nwankwo (1987) recollects and records his conversation with *Agwu* – when *Agwu* was asked about himself, he replied:

I am the spark of Divine Essence charged with the responsibility of providing man with tools of existence ... I hold the key to those secrets of creation which man is expected to know and reveal such secrets as are necessary for the advancement of mankind ... in the study of science, philosophy, religion, occultism, mysticism, I am the first port of call. Intelligence, wisdom, knowledge and power is bestowed on those who have received the blessings of the agent of the Almighty God. These privileges are nevertheless without a price and it is that you shall be clean before God at all times of your life. (p. 69). One only needs so little a demonstration as close his/her eyes, stand barefooted on the earth, open wide his arms and solemnly echo: *Agwu gosi m ike gi*! (*Agwu* show me your power) to experience the awe of *Agwu's* divine aura.

ix. **Ibiniukpabi:** It is the divinity of Arochukwu; a female divinity. According to Awolalu and Dopamu (1978), it has the power "to identify sorcerers, witches, poisoners. People also believe that she can make barren women fertile, and give success in trade, fertility of crops and victory in war" (p. 94).

x. **Ojukwu:** Like the Yoruba *Sopono, Ojukwu* is the god of smallpox. It afflicts sinners with smallpox; and its victims are buried in the evil forest.

Spirits in the African Cosmos

The African universe is made up of myriad of spirits. Death is not understood as the final end of the human person. After death, the soul *nkpulobi* goes back to *Chukwu*. Thus, after-life for the African is a life of continuing relationship with the living dead. Life is cyclic: birth, death and rebirth. Those who lived good lives while on earth and died at ripe old age, receiving the appropriate funeral rites, in relation to their status, go to the spirit-land (*Ala-mmuo*), where they continue to live until they reincarnate. On the other hand, those who lived bad lives or died a bad death, are sent to an intermediate state, between the spirit-land and the land of the living where they live frustrated, as wandering and restless spirits. They are referred to as *ndi Akalogheli* (bad spirits).

Apart from *ndi Akalogheli*, we have the ancestors. Metuh (1991), argues that they are under the presidency of the *Ala* deity. They are the guidance of morality and the owners of the soil. They occupy a very significant place in Igbo life and religion. Uchendu (1965) avers that ancestors are the invisible segment of the Igbo lineage. Their world and the human world are very similar, just like in the human world, they have their farms, their roads, their markets; the only difference is that while our world is visible, theirs is invisible. They are honoured and not worshipped. The honour given to them is anchored on the principle of reciprocity and philosophy of reincarnation: having been honoured, they are expected to reincarnate and do for the living what they did for them.

Nyamiti (1984) distinguishes two elements that characterize the African concept of ancestorship: *natural relationship*, which usually exists between the ancestor and his relatives, either as parent, brother or sister. It can also be founded on common membership of a clan, tribe, religious sect or society. It can, therefore, either be consanguinous or non-consanguinous. There is also the *sacred* or *supernatural* status of an ancestor, which is the consequence of his/her death. Following the African traditional moral standard, a good life is very significant here, since the ancestor is like a standard for the living.

The Human person in the African Cosmos

African religion and thought is anthropocentric. Man is at the centre of the universe, more central than God. According to Mbiti (1969), "Man is at the very centre of existence and African people see everything else in its relation to this central position of man... it is as if God exists for the sake of man" (p. 92). Corroborating with Mbiti, Metuh (1991) writes that "Everything else in African worldview seems to get its bearing and significance from the position, meaning and end of man" (p. 109). The idea of God, divinities, ancestors, rituals, sacrifices, etc., are only useful to the extent that they serve the needs of man.

The analysis of the Yoruba idea of a human person as *eniyan*, reveals the African concept of man as a being having its origin and finality in the Supreme Being. This implies that the human being in the African universe is

best understood in his/her relationship with God, to whom, he/she is ontologically linked with through his/her *chi* (the spark or emanation of God in each person). Man in African worldview has a purpose and mission to fulfil; he comes into the world as a force amidst forces and interacting with forces. Good status, good health and prosperity are signs of the wellbeing of a person's life-force, and the human being struggles to preserve it through an appropriate relationship with the spiritual forces around him/her.

The goal of every human person is to achieve his/her *akara chi* (the destiny imprinted on his/her palm by his *chi*). He is not just an individual person, but one born into a community whose survival and purpose is linked with that of others. The human person is first a member of a clan, a kindred or a community.

Although the human person comes from God, his/her birth is not a separation from God, but still relates with the divine in a community of ways: Through ***libation***: which are prayers usually said in the morning time or during ceremonies, meetings and gatherings using *oji* (kola nut) and *mmanya-oku* (hot drink), the food and drink of the gods. Ijiomah (2005) writes that in prayer, "the Igbo man tries to normalize the relationship among the three worlds ... libation is made to God through the agency of the ancestors and other deities" (p. 87). **Through divination**: which involves a process of inquiry, people who wish to know why certain things happen, how to solve certain problems and so on, go to diviners.

Conclusion

The African worldview is a unified reality. There is a strong interaction between the spiritual and the physical. The interaction of the two worlds instils a greater sense of the sacred in the African because he/she sees and feels the presence of the Supreme Being, divinities and spirit beings (ancestors) present. And since the sacred is permeating in everything, he/she gives a place to the divine in all he/she does: in politics, in his social life, in his business, in the laws he makes. It is such that when these laws are broken, it is not just settled between humans, the divine is also appeased. This further explains why Mbiti (1969) would argue that the African is notoriously religious. Furthermore, there is a sense of community in which all the inhabitants of the cosmic order exist for one another. No being exists for itself, but exists because others exist. However, at the centre of this universe is the human person, and the preservation and enhancement of his/her life is of a prime value. The divine elements exist to preserve human beings; and human being relate with them to preserve his/her life as well. The divine have relevance only to the extent that man's life is preserved.

References

Abanuka, B. (1994). *A new essay on African philosophy*. Nigeria: Spiritan Publication.

Arinze, F. (1970). *Sacrifice in Igbo religion*. Ibadan: Ibadan University Press.

Achebe, C. (1958). *Things fall apart*. England: Heinemann.

Awolalu, J. O. and Dopamu, P. O. (1979). *West African traditional religion*. Ibadan: Onibonoje Press and Book Industry.

Edeh, E. (1983). *Towards Igbo metaphysics* Chicago: Loyola University Press.

Ejizu, C. I. O. (1986). *Igbo ritual symbols*. Enugu: Fourth Dimension.

Ekwealor, C. C. (1990). The Igbo world-view: A general survey. E. Oguegbu (Ed.). *The humanities and all of us* (pp.29-33). Onisha: Watehword.

Ijiomah, C. (2005). African philosophy's contribution to the dialogue on reality issues. *Sankofa: Journal of the Humanities.3. 1.* 81 – 90.

Idowu, E. B. (1962). *Olodumare: God in Yoruba belief.* London: Longman.

Idowu, E. B. (1973). *African traditional religion: A definition.* London: SCM.

Isichie, E. (1969). Igbo and Christian Beliefs: Some aspects of theological encounter. *In African Affairs. 68.* 124.

Kanu, I. A. (2012). A metaphysical epistemological study of African Medical practitioners. In O. E. Ezenweke and I. A. Kanu (2012). *Issues in African traditional religion and philosophy (227-240).* Jos: Fab Anieh.

Metuh, I. E. (1991). *African religions in Western conceptual schemes.* Jos: Imico.

Metuh, E. I. (1987). *Comparative studies of African Traditional Religion.* Onitsha: Imico.

Madu, E. (2004). *Symbolism in African cosmology: The Igbo perspective.* Nnamdi Azikiwe University, Awka, Anambra State. Lecture Note.

Madu, J. E. (2004). *Honest to African cultural heritage.* Onitsha: Caskan.

Mbiti, J. S. (1969). *African traditional religion and philosophy*. Nairobi: East Africa Educational Publishers.

Nwankwo, N. (1987). *In defence of Igbo belief system – A dialectical approach*. Enugu: Life Paths.

Nyamiti, C. (1984). *Christ as our ancestor: Christology from an African perspective*. Zimbabwe: Mambo.

Onunwa, U. (1994). The individual and community in African Traditional Religion and society. *The Mankind Quarterly.34. 3.* 249 – 260.

Onuoha, E. (1987). *Four contrasting world-views*. Enugu: Express.

Unah, J. (2009). Ontologico – epistemological background to authentic African socio-economic and political institutions. A F. Uduigwomen (Ed.). *From footmarks to landmarks on African philosophy* (264 – 278). Lagos: O. O. P.

Oguejiofor, J. O. (2010). The resilient paradigm: Impact of African worldview on African Christianity. In U. U. Bede (Ed.). *God, Bible and African Traditional Religion*(99-112). Enugu: SNAAP.

Oduwole, E. (2010). Personhood and abortion: An Africa perspective. M. F. Asiegbu and I. C. Chukwuokolo (Ed.). *Personhood and personal identity: A philosophical study* (pp. 97-106). Enugu: SNAAP.

Quarcoopome, T. N. (1987). West African traditional religion. Ibadan: African Universities Press.

Uchendu, V. C (1965). *The Igbos of South East Nigeria*. London: Rinehart and Winston.

Wambutda, D. N. (1986). The interplay between cosmology and theology: A. matrix for African theologizing. In A. Oduyoye (Ed.). *The state of Christian theology in Nigeria, 1980-81,* (38-49). Ibadan: Day Star.

TOWARDS AN AFRICAN PHILOSOPHY OF SCIENCE

Introduction

Walter Rodney whom Harding (2009) describes as "the revolutionary scholar and the scholar revolutionary, the man of great integrity and hope" (p. xi), in 1972 published the work known as *How Europe Underdeveloped Africa*. In this wonderful piece he discussed the meaning of development, which he distinguished from underdevelopment. With this clarification of concepts, he was preparing the background for his study on the consequence of the encounter between the West and Africa. In chapter two of this work, Rodney (1972) discusses how Africa developed until the 15th century before the advent of the Europeans. He established the principle that contact between societies change their rates of development, and in relation to the contact between the West and Africa, he argues that the contact was ruled by exploitation, the discarding of traditional systems to speed up the capitalist agenda, evident are the events of the slave trade and colonialism, which ended in the underdevelopment of Africa and, thus, the losing of the sciences and technologies that had prevailed in Africa.

Scholars like Blatch (2013) who argues in favour of the achievements of science and technology in ancient Africa, observes that the contributions of ancient Africa to science and technology is not referred to in the writings of European historians. While reference is made to the Greeks, Romans and other Western civilizations, no reference is made to the contributions of Africa. It is in this regard that Sertima (1983) avers that "the nerve of the world has been deadened for centuries to the vibration of African genius" (p. 7). Although there are times when references were made to Egypt, the history of Africa beyond ancient Egypt is hardly publicized. The result is that many are not aware of this culture of achievements, the sophistications and impressive inventions that were obtainable in ancient Sub-Saharan Africa. This chapter, therefore, concerns itself with a historico-philosophical investigation of ancient Africa in the area of science and technology. It further raises questions as regards the disconnection between the achievements of ancient Africa and the present.

Science and Technology in Ancient Africa

The contribution of Africa to ancient civilization in terms of science and technology covers a wide area. These areas include mathematics, medicine, astronomy, metallurgy, navigation, architecture etc. However, for the purpose of this research, only four achievements will be studied: mathematics, medicine, astronomy and metallurgy.

Disciplines of African Philosophy

1. Mathematics

Generally, mathematics develops according to the need of the society. The complexity of a society would be reflected in its developments in the area of mathematics, evident in the use of complex set of numbers for a complex count of objects. If a society is simple, it would employ simple set of numbers for simple counts of objects. In ancient African societies, which were less complex, Africans had their own mathematical systems which was developed according to the need of the time.

Between 9000 BC and 6500 BC, in the Democratic Republic of Congo, among the Ishango who lived along Lake Edward, developed their numbering system which was carved on bones. This was the earliest manifestation of the use of numbering in Africa, discovered during the excavation of the border cave in the Lebomba mountains, between South Africa and Swaziland. The piece of bone is a fibular of a baboon about 7.7cm long. During the course of this study, the researcher was intrigued by the markings on the bones

A diagram of the Ishango bone culled from www.thestargarden.co.uk

A diagram of the Ishango bone with illustrations culled from www.thestargarden.co.uk

In the first column categorized as G, there are four groups made up of the prime numbers 11, 13, 17 and 19. By prime number, is meant any numbers that cannot be divided by any other number except by itself. In another column categorized D, there are four numbers: 11, 21, 19 and 9. The pattern in this column might be 10+1, 20+1, 20-1, and 10-1. In the third column categorized as M, we have numbers 3, 6, 4, 8, 10, 5, 5, 7. This arrangement is strongly related to a theory of doubling.

According to Dr. Jean de Heinzelin who discovered the Ishango bone and Peter Beaumont who did a profound study of the bone, the bone resembles the calendar stick used by the bushmen clans in Namibia. The functions of this bone include:
1. multiplication, division and other simple mathematical calculations,
2. a six month lunar calendar,
3. a construct of a woman keeping track of her menstrual circle.

Among the Yoruba of Southern Nigeria, Zaslavsky (1983) avers that they had a complex number system, which was based on the number 20. It relies heavily on subtraction rather than addition. For instance, 45 would be written thus: 20 x 3-10-5. 106 would be written thus: 20x6-10-4. Spalinger (1985) had also made reference to an Egyptian numbering system with its own number 0. According to Lumpkin (2002 and 2013), the number zero is evident in the zero reference level marked on construction lines in old Egyptian kingdom pyramids and tombs that were constructed about 2,700 years ago. Balance sheets for record keeping dating to about 3700 years BC have been discovered in Egypt, which is an evidence of mathematics in the ancient African.

2. Medicine

Thousands of years ago, Africans, precisely ancient Egypt made enormous contributions in the area of medicine. In the West, the developments in the area of medicine dates back to the successes of Greek medicine men and women like Hippocrates and Galen; however, Finch (2001) argues that Greek medicine owes so much to the priests physicians of Egypt. The dependence was so strong that the Greek healing deity, Asclepios was identified with the Egyptian physician-architect Imhotep, a god of healing who was formerly the doctor of Pharoah Zoser in the 3rd millenium.

In the administration of medicine in ancient Egypt, there was a strong interpenetration of the magico-spiritual and the rational. As far back as 5000 years ago, textbooks in the area of medicine were already written indicating the level

of civilization and development in this area of knowledge. Flinch (2001) writes that:

The extant medical papyri show us that the Egyptians had quite an extensive knowledge of anatomy and physiology. They understood the importance of pulsation and - 4500 years before Harvey - knew something of the structure and function of the cardiovascular system. They knew that the heart was the center of this system, had names for all the major vessels, knew the relation between heart and lung, and knew the distribution of the vessels through the limbs. They had names for the brain and meninges (the covering of the brain and spinal cord) and also seem to have known the relation between the nervous system and voluntary movements. (p. 1).

The ancient African diagnostic method was not different from the modern one. When the physician comes to examine a patient, the Egyptian extant papyri directs the medical personnel to begin with a careful observation of the patient's general appearance, observing the color of the face and eyes, the quality of nasal secretions, the presence of perspiration, the stiffness of the limbs or abdomen, and the condition of the skin, the smell of the body, sweat, breath, and wounds, the urine and feces, the pulse palpated and measured, and the abdomen, swellings, and wounds probed and palpated. This would be followed by questions directed to the patient.

Thousands of years ago, Egyptians already understood the importance of pulsation. According to Woods (1988), they knew the structure and function of the cardiovascular system. They knew that the heart was the center of this

Disciplines of African Philosophy

system, had names for the major vessels of the body. The medical papyri of the surgical Edwin Smith Papyrus, which is a compendium of Egyptian anatomical knowledge and surgical methods reports that the Egyptians and other African traditional societies were already engaged in surgery under antiseptic conditions thousands of years before encounter with the West.

Felkin (1884) made an illustration of a Cesarean section performed by indigenous healers in Kahura, Uganda. During the surgery, the healer used banana wine to semi-intoxicate the woman and to cleanse his hands and her abdomen prior to surgery. He used a midline incision and applied cautery to minimize hemorrhaging. He massaged the uterus to make it contract but did not suture it; the abdominal wound was pinned with iron needles and dressed with a paste prepared from roots. The patient recovered well, and Felkin concluded that this technique was well-developed and had clearly been employed for a long time.

A Cesarean section performed by indigenous healers in Kahura, Uganda culled from Felkin 1884.

Worthy of note is that before the West, Africa already had the medical procedure of vaccination, autopsy, limb traction, broken bone setting, bullet removal, brain surgery, skin grafting, filling of dental cavities, installation of false teeth, etc. They used more than one thousand animals, plants and mineral products to treat illnesses. Night blindness, caused by vitamin 'A' deficiency, was treated with ox livers, patients with scurvy caused by vitamin 'C' deficiency were fed onions, a known source of vitamin 'C', castor seeds, the source of castor oil, were used to make cathartic preparations, plants with salicyclic acid were used for pain, Kaolin for diarrhea, and extracts that have been confirmed in the 20th century to kill Gram positive bacteria.

From the foregoing, Flinch (2001), among other scholars argues that medicine as known today began in Egypt rather than in Greece. The poverty of documents on the earliest development of medicine in Africa has been determined by the fact that those who wrote our history: Western sociologists, anthropologists, missionaries had great contempt for African culture and so transmitted only what they considered necessary or reasonable. And also, Africa had been through a lot of negative experiences, the slave trade and colonialism particularly, which politically, socially, culturally, economically disrupted the African traditional structures.

3. Astronomy

Woods (1988) asserts that the ancient African society made great contributions to astronomy which modern science still relies on. As far back as 2,150 BC, about 4,000 years ago, ancient Egypt charted the movement of the sun and the circles

Disciplines of African Philosophy

of the moon. It was in Egypt that Thales, the Greek sage received his education; and here he was trained in astronomy. They divided the year into 12, and developed a yearly calendar system that has 365 days. The initial purpose for this development in ancient Africa was to know when to plant their crops. As far back as this period, clocks were already made. As far back as 300 BC, Lynch and Robbins (1983) observe that Kenya already had a remarkable accurate calendar that was based on astronomy. The Fang of West-Coast of Africa (Cameroon and Gabon) also have a 12 month calendar.

The Ancient Egyptian Calendar
Culled from http://emhotep.net/2012/12/31/
em-hotep-digest-vol-01-no-14-feast-and-festivities

Sacred Sothic Year			Alexandrian Year		Julian Year		Ancient Egyptian Seasons
Days	Day	Month	Day	Month	Day	Month	
1	1	Thoth (I)	26	Epiphi	20	July	
6	6	"	1	Mesori (XII)	25	"	
31	1	Phaophi (II)	26	"	19	August	I.
36	6	"	1	Intercalary Days	24	"	The
40	10	"	5	"	28	"	Inundation
41	11	"	1	Thoth (I)	29	"	
61	1	Athyr (III)	21	"	18	September	
71	11	"	1	Phaophi (II)	28	"	
91	1	Khoiakh (IV)	21	"	18	October	
101	11	"	1	Athyr (III)	28	"	
121	1	Tybi (V)	21	"	17	November	
131	11	"	1	Khoiahk (IV)	27	"	
151	1	Mechir (VI)	21	"	17	December	II.
161	11	"	1	Tybi (V)	27	"	Winter
181	1	Phamenoth (VII)	21	"	16	January	
191	11	"	1	Mechir (VI)	26	"	
211	1	Pharmuthi (VIII)	21	"	15	February	
221	11	"	1	Phamenoth (VII)	25	"	
241	1	Pachons (IX)	21	"	17	March	
251	11	"	1	Pharmuthi (VIII)	27	"	
271	1	Payni (X)	21	"	16	April	
281	11	(Payni)	1	Pachons (IX)	26	"	III.
301	1	Epiphi (XI)	21	"	16	May	Summer
311	11	"	1	Payni (X)	26	"	
331	1	Mesori (XII)	21	"	15	June	
341	11	"	1	Epiphi (XI)	25	"	
361	1	"	21	"	15	July	
365	5	Intercalary Days	25	"	19	"	

The Ancient Egyptian Calendar
Culled from <http://emhotep.net/2012/12/31/em-hotep-digest-vol-01-no-14-feast-and-festivities>

The Dogon people of Mali according to Adams (1983) for a long time before contact with the West already knew of Saturn's rings, Jupiter's moons, the spiral structure of the Milky Way and the Orbit of the Sirius star system. Their initial concern was to fix dates for their festivals, rituals, optimum planting and harvest times and in the process discovered the mysteries of the elements of the heavens. Although not visible to the naked eye, they knew that the Sirius star system had primary and secondary stars now referred to as Sirius B, the brightest star in the sky. They refer to it as the egg of the world. According to the Dogon tribe,

Disciplines of African Philosophy

Sirius B has an elliptical orbit around Sirius A that takes 50 years to complete. Modern science has confirmed this.

Figure 7. The linear extension on the right is scientifically reliable, based on measurements of the rate of revolution of Sirius B around Sirius A. The linear extension on the left is not scientifically reliable. It is a presumed correlation, for there is no way in which the rate of revolution of Digitaria can be known certainly from the Dogon information. These linear extensions cannot, therefore, be considered to constitute hard evidence of a correlation. It is likely, though, that they do correlate because Digitaria is presumed to move at a rate which makes astronomical sense (for if the shape of the orbit and the distance match, the period should match)

Culled from <http://www.ancient-code.com/the-dogon-tribe-connection-sirius/>

Above is the Dogon tribal diagram the course and trajectory of this star until 1990. The Dogon tribe observed that the star is made of metal, which was brighter than iron of which if all human beings on earth were a lifting force, they would not be able to move it. Modern science also confirmed this when it described it as being compacted that its mass may be many times greater than a star, which appears many times bigger. The Dogon further observed that this star has an orbit of one year around its own axis. They have a celebration called *Bado* held in honour of that orbit.

Figure 6. On left: the orbit of Digitaria (Sirius B) around Sirius as portrayed by the Dogon in their sand drawings. On right: A modern astronomical diagram of the orbit of Sirius, the years indicated being the positions of Sirius B in its orbit on those dates. Note that the Dogon do not place Sirius at the centre of their drawing but seem to place it near one focus of their approximate ellipse – which constitutes one of the most extraordinary features of their information, and matches the diagram on the right to an uncanny degree

A Dogon Tribal drawing of the Orbit of Sirius B around Sirius
Culled from http://www.ancient-code.com/the-dogon-tribe-connection-sirius/

The Dogon knowledge of these heavenly bodies has remained a mystery that sent shock waves around the scientific world. Two French anthropologists are significant in the publication of the Dogon tribal observations about Sirius B: Marcel Griaule and Germaine Dieterlen. They studied the Dogon people from 1931-1956; living with the people worked with them, were initiated into the tribe and went through the Dogon system of education in order to learn the Dogon secrets of the universe, which concerned the realization of the nature of creation, the creation of stars and spiraling galaxies, the creation of plants and the purpose of human existence. Such details about realities that only the most advanced observations can detect are what has continued to shock the scientific world.

4. Metallurgy

Metallurgy, according to Wikipedia (2015) is "a domain of material science and engineering that studies the physical and chemical behavior of metallicelements, their intermetallic compounds, and their mixtures, which are called alloys" (p. 1). It further added that metallurgy includes:

The way in which science is applied to the production of metals, and the engineering of metal components for use in products for consumers and manufacturers. The production of metals involves the processing of ores to extract the metal they contain, and the mixture of metals, sometimes with other elements, to produce alloys. Metallurgy is distinguished from the craft of metalworking. (p. 1).

Brooks (1971) observes that across the entirety of ancient Africa, there were advancements in metallurgy and tool making. According to Shore (1983), developments in metallurgy in places like Tanzania, Rwanda and Uganda between 1,500 and 2,000 years ago were far ahead that of Europe and sent shocking waves to the Europeans when they came to Africa. In fact, Peter Schmidt and Donald Avery of the Brown University, USA, historical anthropologist and engineer respectively, who worked together among the Haya people of Lake Victoria, argue that Africans who lived in Lake Victoria, in Tanzania had produced carbon steel as far back as 2,000 years ago. They observe that the furnaces of ancient Tanzania could go as far as 1,800 degree centigrade – 200 to 400 degree centigrade warmer than those obtainable in Rome.

Tools used in Ancient Africa
Culled from *http://atlantablackstar.com/2014/10/01/12-African-invention-that-changed-the-world/3/*

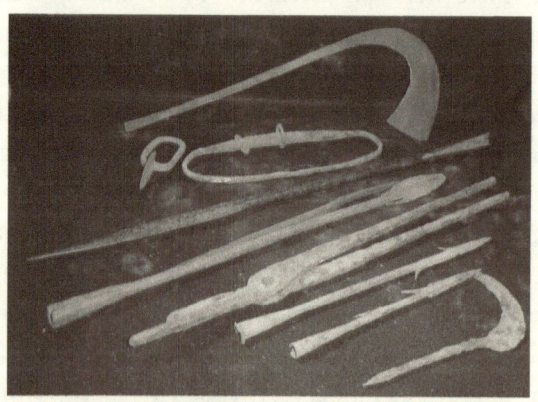

***Tools Excavated by archeologists from
the Lion Cave in Swaziland***
Culled from *http://atlantablackstar.com/2014/10/01/12-African-invention-that-changed-the-world/3/*

Disciplines of African Philosophy

The use of such tools that have been excavated by archeologists from the Lion Cave in Swaziland, which radiocarbon dating indicates to be about 43,000 years old points to the fact of metallurgy in ancient Africa. The ancient Egyptians mined a mineral called malachite and Nubia and had gold mines that were among the largest and most extensive in the world. Tools made at the time include steam engines, metal chisels and saws, copper and iron tools and weapons, nails, glue, carbon steel and bronze weapons and art.

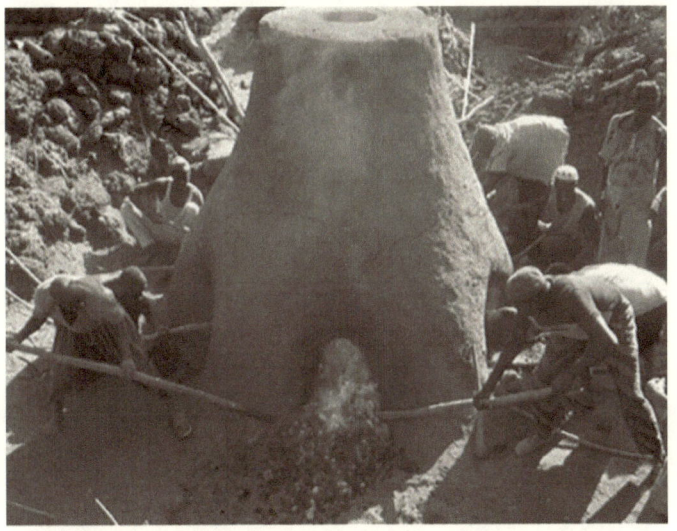

A traditional furnace for smelting iron in Mali
Culled from *http://www.crystalinks.com/dogon.html*

The method employed during the ancient period according to Professor Schmidt was the *pre-heated forced-draft furnaces* which was technologically more sophisticated than the methods obtainable in Europe

until the mid 9th century. With the advent of colonialism, Emeagwali (2013) avers that metallurgy was the first hit. It inhibited the development of indigenous technology in Africa by bringing a shift from the existing process of technical growth to a cash crop economy.

Africa and Ideological Race Classification

These achievements in ancient Africa in the areas of science and technology, reveals a perspective that is contrary to the popular opinion of the seventeenth century philosophers, anthropologists and sociologists that furthered the idea that Africans are not capable of reason. The idea of the birth of modern science in the 17th century, a period of intellectual activity by Europe, is also questioned by these achievements of Africa before the 17th century. If Africans were really able to achieve this level of scientific and technological height, it would mean that these opinions were emotionally based.

It was Hegel (1956) who posited that the Negro is yet to go beyond his instinctual behaviour to identify a being outside of himself:

In Negro life the characteristic point is the fact that consciousness had not yet attained to the realization of any substantial existence.... Thus distinction between himself as an individual and the universality of his essential being, the African in the uniform, undeveloped oneness of his existence has not yet attained. (p. 93).

Following the same line of thought, Levy-Bruhl (cited by Njoku 2002), questioned the veracity of an untutored African knowing about God. For him, the African way of thinking is non-logical and full of inner self-contradiction. Corroborating with Levy-Bruhl, Baker (cited in Njoku 2002) writes:

The Negro is still at the rude dawn of faith-fetishism and has barely advanced in idolatry.... he has never grasped the idea of a personal deity, a duty in life, a moral code, or a shame of lying. He rarely believes in a future state of reward and punishment, which whether true or not are infallible indices of human progress. (p. 199).

Considering these perspectives and the achievements of Africa in the ancient period, a couple of questions begin to arise. If Africa was at the based, far apart from Europe, how then were Africans able to develop in science and technology, in some quarters far beyond the developments obtainable in Europe at the time? If the black race is closest to lowest animals, from where then came the faculty to register this level of advancement? If one has not achieved self-consciousness, such level of achievement would be far from him or her. Ancient Africa's great achievements in the area of science and technology reveal that the ideological race classification of Africa was emotionally based.

The idea that regions outside Europe contributed nothing to the development of science and technology and have only been passive recipients of Western civilization is a myth. According to Emeagwali (2014), there is silence with respect to the non-European predecessors of significant inventions.

There is also the Westernization of the names of outstanding scientists and the Europeanization of scientific documents as a ploy to undermine the fair assessment of the global multiregional history of science and technology. There is also the problem of double standards in the assessment of scientific and technological achievements as most achievements from Africa are deliberately trivialized.

Conclusion

The claim of great achievements in science and technology in ancient Africa by both Western and African scholars does not offer enough consolation to the African who thinks of himself or herself as relegated to the background of ancient civilization. It rather does more of revealing a huge missing link between the great achievements of the past and the poverty of the present's contribution to the modern world. If the achievements of Africa in the past would be taken seriously, there is the need for a causal link of the present to a past action. The great achievements of the past can only make sense when they are employed as a wake-up call to the African than as a disproof of the obvious that the African is backward. It is very difficult to prove and relate such achievements against the present backwardness of the black race. Instead of Africans glorying in a past that is hardly related to the present, the African should see the missing link between the present and the past and work hard to become like his/her ancestors. There are times that Africans have tried to explain the present missing link or predicament by reference to the effects of slavery and colonialism; these explanations are not enough. If the African wants to prove

that he/she has not been absent in the history of human civilization, what he/she should busy himself/herself doing is to repeat his/her past contribution to human civilization in the present. Let the present predicament be a push for the African to reshape his destiny and be part of the decision-makers that are building a new world order. If the ancestors of Africans were great in the past, why can't their predecessors?

References

Adams (1983). African observers of the universe: The Sirius question. In I. V. Sertima (Ed.). *Blacks in science: Ancient and modern* (pp. 27-46). New Brunswick: Transaction Books.

Blatch, S. (2013). Great achievements in science and technology in ancient Africa. *ASBMB Today February.* 1-13.

Brooks, L. (1971). *African achievements: Leaders, civilizations and cultures of ancient Africa*. USA: Paperback.

Emeagwali, G. (2013). *Colonialism and Africa's technology.* Retrieved 16th January 2015 from http://www.africanhistory.net/colonialism.htm.

Emeagwali, G. (2014). *Eurocentrism and the history of science and technology.* Retrieved 16th January 2015 from http://www.africanhistory.net/eurocentrism.htm.

Felkin, R. W. (1884). Notes on labour in Central Africa. *Edinburgh Medical Journal, 20.* 922-930.

Flinch, C. (2000). *African background of medical science.* Retrieved 13th January 2015 from http://raceandhistory.com/selfnews/viewnews.cgi?newsid995545990,4925,.shtml.

Harding, V. (2009). *Introduction*. In How Europe Underdeveloped Africa (pp. xi-xxx). Lagos: Panaf Publishing.

Hegel, G. W. F. (1956). The philosophy of history. New York: Dover.

Lumpkin, B. (2002). Mathematics used in Egyptian construction and book keeping. *The Mathematical Intelligencer.* 24. 2. 20-25.

Lumpkin, B. (2013). *Mathematics in ancient Egypt*. Retrieved 13th January 2015 from http:/www.africanhistory.net/lumpkin.htm.

Lynch, B. M. and Robbins, L. H. (1978). Namoratunga: The First Archeoastronomical evidence in Sub-Saharan Africa. *Science.* 4343. 766-768.

Njoku, F. O. C. (2002). *Essays in African philosophy, thought, theology.* Enugu: SNAAP.

Izu, O. M. (1997). *Africa: The question of identity.* Washington: The Council for Research in Values and Philosophy.

Rodney, W. (1972). *How Europe underdeveloped Africa.* Lagos: Panaf Publishing.

Sertima, I. V. (1983). The lost sciences of Africa. In I. V. Sertima (Ed.). *Blacks in science: Ancient and modern* (pp. 7-26). New Brunswick: Transaction Books.

Shore, D. (1983). Steel-making in ancient Africa. *Blacks in science: Ancient and modern* (pp. 157-162). New Brunswick: Transaction Books.

Spalinger, A.(1985). Notes on the day summary accounts of P. Bulaq 18 and the intradepartmental transfers. *Studien Zur Altaegyptischen Kultur.* 12.

Wikipedia (2015). *Metallurgy*. Retrieved 16th January 2015 from http://en.wikipedia.org/wiki/Metallurgy.

Woods, G. (1988). *Science in ancient Egypt*. USA: Grolier Publishers.

Zaslavsky, C. (1983). The Yoruba number system. In I. V. Sertima (Ed.). *Blacks in science: Ancient and modern* (pp. 110-127). New Brunswick: Transaction Books.

TOWARDS AN AFRICAN ETHICS

Introduction

Many ethnologists, sociologists, anthropologists and even missionaries have argued that Africans cannot distinguish between good and evil, and that even if they give considerations to issues of this kind, it is always savage in character: a system that cuts morality to ribbons. Pointing out the colonial mentality or perspective about African sense of morality in his time, Tempels (1959) writes:

> On the subject of theft, it is generally said that the African does not see the least wrong in it, that the only thing that matters is not to get caught. Lies and deceit, it is said, are, in African eyes indications of subtlety of mind, countenanced by all moral assessment. They would not regard adultery as any infraction of morality and it would suffice if anyone caught in the act should agree to pay an indemnity. (p. 54).

Disciplines of African Philosophy

The difficulty of acknowledging that Africans have a morality by Western scholars is based on the differences in the Western and African moral systems. In the Western moral theory, the social order is mere conformity with conventionalized behaviour; however, for the African, morality and moral laws are based on belief and unshakable principles that are tied to ontology and held from conviction. The African like all peoples have a sense of good and evil, which is not left in the air but taken from philosophical concepts and the knowledge of God. Tempels (1959) therefore, defends the existence of Bantu-African ethics as follows:

> The Bantu likewise reject lies, deceit, theft and adultery, on the same fundamental grounds of the destructiveness inherent in them. They also condemn, as Bantu, various very widespread usages such as polygamy, child marriage and other sexual abuses. In short, they know and accept Natural Law as it is formulated in the Ten Commandments. (p. 56).

Traditional African societies had had their traditional ethics. This chapter would therefore, explore its ontological foundations, the link between the African community and ethics, and the nexus between African ethics and religion.

From Ethics to African Ethics

Ethics generally, is a field of study which deals with the morality of human actions or the norms of human behaviour. Ethics is commonly used interchangeably with

morality to mean the subject matter of this study. Omoregbe (1993) defined it as "the systematic study of the fundamental principles of the moral law; or as the normative science of human conduct" (p. 4). According to Thiroux (1998), it deals with the right and wrong of human behaviour and conduct. That is the question of what constitutes the right or wrong, good or bad in a person's action? What theories are right or wrong in evaluating human action? This establishes the relationship between ethics and epistemology.

Gonsalves (1972) traces the beginnings of ethics to life situations:

> Ethics grows out of life situations in which we are confronted with some sort of perplexity or doubt about what is the right thing to do or the best course to follow, situations in which different desires strive for opposed goods or in which incompatible courses of action seem to be justifiable. Such conflict situations call forth personal enquiry into the reasons for deciding where the right really lies. (p. 3).

In describing the purpose or task of ethics, the analytic school of philosophy reduced the task of ethics to analyzing and clarifying moral concepts. Hare (1970) had posited, in the representation of the analytic school of philosophy that ethics is the logical analysis of moral language. Ayer (1971) had also imposed on the entire system of philosophy the task of analysis of concepts. Contrary to their opinions, Lewis (1963) had argued that ethics is much more than the analysis and clarification of language, even though the analysis of language is useful. From the foregoing, African ethics would

therefore refer to the salient features or ideas of the African moral life and thought generally as reflected in, or generated by, African moral language and social structure and life.

African Ontology as the Foundation of African Ethics

The African universe is governed by the spirit of harmony, with an influence and a hierarchy of forces that reveals a universe of coordinated forces. There is harmony between the physical and spiritual worlds and the human person who is at the centre of the African universe relates with every dimension of this world. As a result of the harmony in the African universe, what happens at other dimensions of the universe, that is, the world of *Chukwu* and the world of the spirits, also comes knocking at the human world. This harmony of the universe is from God; he summons it into being, strengthens it and preserves it. They are in fact one. The human person who is at the centre of this universe must tune himself to the different dimensions of his universe for his well being. Madu (2004) writes:

> Health for the Igbo means a harmonious existence between the different spheres of the cosmic order in which man is a member. For man to say that he is healthy or alive therefore means that man should tune himself with the other forces of the cosmic order (p. 25).

The harmony of the universe is an essential condition for the wellbeing of the African.

In relation to morality, objective moral law for the African is ontologically based; it is based on the things ontologically understood. Thus, when an action is considered ontologically good, it is also considered morally good and juridically just, however, if it is considered ontologically evil, it will be considered morally evil and juridically unjust as well. Actions such as murder would be considered a conspiracy against God and as such an ontological sacrilege. It is reprehensible in the sight of God who is the giver and preserver of all life. This explains why when a person commits an offence he offers sacrifices to god through the gods or ancestors, this is because an action could touch on the other dimensions of the African universe. Every other law that is worth its name must be based on this philosophy. The differentiation of actions as good or bad is based on the divine will which is expressed in the ontological order. Gyekye (1987) avers that, "Just as the good is that action or pattern of behaviour which conduces to well-being and social harmony, so the evil is that which is considered detrimental to the well-being of humanity and society" (p.133). The social order is founded on the ontological order. To renounce the ontological order is to renounce African ethics and law.

African Community and African Ethics

As a consequence of the central place the community occupies in African ontology, personhood is strongly linked to the community. African philosophy accepts that personhood is something attained in direct proportion as one participates in communal life through performing the various duties imposed on him or her by living in the

community. A person is defined by reference to his kinship, and as such, the reality of communal world takes precedence over the individual. Mbiti (1969) sums up the African view of a person in these words: "I am because we are, and since we are therefore I am" (p. 108). This does not mean that the hold which the community has over the individual African is not so constructive that the expression of individuality is completely frustrated. On the contrary, individuality, instead of being frustrated, is helped and defined by the community. The community in Africa survives on the contributions of individual endowments. Thus, Chidili (1993) avers that the African admits pluralism, but harnesses it and makes proper use of it.

The central place of the community and the relationship between the community and the individual has strong implications for African Ethics. First, there is a strong connection between moral rules and the type of communal kinship relationships that exist among African societies. A crime committed by a person, say stealing, has implications not only for the thief but also for the kinship relationship; for what is stolen is first of all considered to be a thing of the member of the kinship, perhaps of one related to the thief in one way or the other. The offence not only affects the victims of the theft but the whole community, and the shame as well also goes to the whole community. In some quarters, the punishment not only affects the thief but also the close relatives, as in the case where a person is asked to leave the village with his entire family. The community is involved because of the ontological connection. Edeh (1985) wrote:

> From the Igbo idea of community founded on love and brotherhood, it is easy to discern that for the Igbos any evil, physical or moral, even though personal, has a community dimension. An evil is considered such because it fractures the ultimate whole of life; it causes a break in an existential unity. (p. 106).

The community has a responsibility in rooting out evil, and more so, the responsibility in helping the person concerned. There is an African proverb that says: *A kinsman who strays into evil must first be saved from it by all, then, afterwards be questioned on why and how he dared stray into it to start with.* According to Edeh (1985):

> The most important point here is that an evil, be it committed by an individual or group, is the concern of the whole community… the community does not leave the delinquent in isolation. He is always recognized as an indispensable part of the whole. Yet the evil is not condoned, and the culprit is not hidden away or helped to escape. Rather, the whole community comes out to eradicate the evil. (p. 106).

In Western ethics there is an emphasis on the absolute rights and choices of the individual. For instance, as in the case of a mother who decides to abort her child on the basis that it is her child. In African ontology, life is not a personal thing. It is a community affair, involving both the physical and spiritual worlds. This explains why the community prepares for the coming of the child and secures its future within the community. The Igbo would thus say: *Ebulu nwa n'afo, o*

bulu nwa ofu onye; amuo ya, o bulu nwa oha (When a baby is in the womb, it is the child of one person, when it is born, it becomes the child of the community). Individual choices are not always right; they could be conditioned by personal interests or even psychological deformity.

African Ethics and African Religion

Kanu and Paul (2011) observes that in Africa, there is widespread belief in a Supreme God, with a profound sense of the sacred and mystery. Thus, it is difficult to separate the life of the African from his personal inclinations to the divine. It is in this regard that he does everything with the consciousness of God. Mbiti (1969) puts this succinctly:

> Wherever the African is, there is his religion. He carries it to the fields where he is sowing seeds or harvesting new crop, he takes it with him to a beer parlour or to attend a funeral ceremony; and if he is educated, he takes religion with him to the examination room at school or in the university; if he is a politician, he takes it to the house of parliament. (p. 2)

In the contention of Njoku (2004), this aspect of his daily life is such that,

> The African man had many taboos to observe, and many daily rituals to perform, either to appease the community or the divinities. If he was not an indirect or unconscious slave of the dominant

> conscious, he held perpetual allegiance to one divinity or another. If he was 'free' with men, he was not free with nature or his environment. Suppose community and environment allow him to live his life with fewer burdens, he would still have to pay the debts owed by his past ancestors. (p. 57).

It is on the basis of these perspectives that Opoku (1974) avers that "It may be said without fear of exaggeration that life in the Akan world is religion and religion is life". (p. 286). Opoku (1978) connecting the interpenetration of religion to morality wrote that "Generally, morality originates from religious considerations, and so pervasive is religion in African culture that ethics and religion cannot be separated from each other" (p. 152). Sarpong (1972) stated that "Ethics here emerges with religion and religious practices" (p. 41). Busia (1967) also wrote that "Religion defined moral duties for the members of the group or the tribe" (p. 16). Agreeing with these perspectives, Danguah (1944) avers that "Everything has value only in relation to the idea of the great ancestor" (p. 3).

Gyekye (1987) rejected the link established by these scholars between religion and morality as mistaken. He observed that these scholars speak of morality only in terms of moral rules or norms, while forgetting that morality involves the conduct of people or the pattern of behaviour. It is therefore not clear if these perspectives are of the view that morality is bound up with religion or if it is that religious beliefs influence human actions, or if both is meant. The reason of Gyekye distancing religion from morality was based on

Disciplines of African Philosophy

his research among the Akan people of Ghana in which he discovered that the concepts of good and evil are used not because the divine has sanctioned them, but because it helps humanity. He thus, prefers to talk of a humanistic or non-supernaturalistic origin of morality rather than a religious origin of morality which emphasizes the wellbeing or welfare of the community. Wirendu (1983), Summer (1983) and Oluwole (1990), while arguing for the Akan, Ethiopian and Yoruba ethics respectively, had written in the same terms when they argued that African morality is founded on rational reflection, that is, as to what is conducive to human welfare.

While the above perspectives is plausible, it needs to be said that when African scholars say that there is a link between religion and morality, it is not intended to say that God has commanded such a morality but that the failure to fulfill that law would attract punishment from God. Omoregbe (2005) would not have concluded that it is a perspective held by religious men for that would mean that all those who have held that perspective are religious men. That was a hasty generalization and an easy way out explaining a position. Another question that may arise is: what does Omoregbe means by religious men? Does he mean those who have a religion or those who are clergy men? The word 'religious men' is ambiguous. To counteract the idea that religion has a link with morality, he spoke of "those who have no religious beliefs at all" (p. 36), but he forgets that the focus of his thought is on *Ethics in Traditional African Society*. To learn of men who had no religious belief at all in traditional African society would be a new and interesting knowledge.

More interesting is the fact that Wirendu (1983) and (1995), as cited by Omoregbe said that the people he interviewed among the Akan people all interpreted morality from a purely non-supernaturalistic perspective. This does not sound real. Reading further, Omoregbe interprets Tempels' statement that: "Bantu moral standards depends on things ontologically understood" thus, "By this Tempels wishes to express the truth that the Bantu people see morality not as an arbitrarily creation of the gods or anybody but as something demanded by the very nature of things" (p. 40). Omoregbe may need to read other parts of Tempels work where he wrote that: "Like all primitive people (and semi-primitive) people, the Bantu turn to their philosophical concepts and no less towards their knowledge of God to draw out the principles and the norms of good and evil" (p. 53).

It is true that morality is not religion, but to argue that morality has no relationship with religion sounds plausible but not real. It was not so much about that God has given the moral law, but that these laws when broken offends him and the ancestors who upheld them. God is part of the ontological order, and to do anything that harms the human person is to distort the ontological order and thus would attract divine wrath. In African traditional societies there was the fear of the ancestors and divinities. The idea of the relation of morality to the divine gave morality a strong value in African traditional societies and further affected behaviour, that is, the response of men and women to that law. African ethics therefore, has both a religious and humanistic basis. It is religious and humanistic at the same time because in African ontology, the human person occupies the central place.

References

Ayer, A. J. (1971). *Language, truth and logic*. London: Penguin.

Busia, K. A. (1967). *Africa in search of democracy*. New York: Praeger.

Chidili, B. (1993). *Rediscovering Christianity in African cultures*. Kenya: Pan Printers.

Danguah, J. B. (1944). *The doctrine of God: A fraction of Gold Coast ethics*. London: Lutterworth.

Edeh, E. (1985). *Towards ab Igbo metaphysics*. Chicago: Loyola University Press.

Gonsalves, M. A. (1972). *Right and reason: Ethics in theory and practice*. London: Merrill.

Gyekye, K. (1987). *An essay on African philosophical thought: The Akan conceptual scheme*. Cambridge: Cambridge University Press.

Hare, R. M. (1970). *The language of morals*. London: OUP.

Kanu, I. A. and Paul, T. H., Ethical and religious values in African traditional religion with Christian analogies. *International Journal of Theology and Reformed Tradition*, *3*. 199-212, 2011.

Lewis, H. D. (1963). *Clarity is not enough*. London: Penguin.

Madu, E. J. (2004). *Honest to African cultural heritage*. Calabar: Franedoh.

Mbiti, J. (1969). *African religions and philosophy*. Nairobi: East African Educational.

Njoku, F.O.C. (2004). *Development and African philosophy: A theoretical reconstruction of African socio-political economy*. New England: Universe.

Oluwole, S. B. (1990). The rational basis of Yoruba ethical thinking. *The Nigerian Journal of Philosophy.* 4. 15-25.

Omoregbe, J. (1993). *Ethics: A systematic and historical study.* Lagos: Joja Educational.

Omoregbe, J. (2005). Ethics in traditional African society. In P. Iroegbu and A. Echekwube (Eds.). *Kpim of morality:Ethics, general, special and professional* (pp. 36-42). Nigeria: Heinemann.

Opoku, K. A. (1974). Aspects of Akan worship. In C. E. Lincoln (Ed.). *The black experience in religion* (pp. 280-296).

Opoku, K. A. (1978). *West African traditional religion.* Singapore: SEP International Private.

Sarpong, P. A. (1972). Aspects of Akan ethics. *Ghana Bulletin of Theology.* 4. 3. 40-54.

Summer, C. (1983). An ethical study of Ethiopian philosophy. In H. O. Odera and D. A. Wasola (Eds.). *Philosophy and culture* (pp.91-101). Kenya: Bookwise.

Tempels, P. (1959). *Bantu philosophy.* Paris: Presence Africaine.

Thiroux, J. (1998). *Ethics, theory and practice.* United States of America: Prentice Hall International.

Wirendu, K. (1983). Custom and morality: A comparative analysis of some African and Western conceptions of morality. *Conceptual decolonization in African philosophy* (pp. 33-52). Ibadan: Straum Limited.

Wirendu, K. (1995). Morality and religion in Akan thought. In H. O. Odera and D. A. Wasola (Eds.). *Philosophy and culture* (pp. 6-11). Kenya: Bookwise.

TOWARDS AN AFRICAN POLITICAL PHILOSOPHY

Introduction

The historical evolution of political systems reveals that over the years, a couple of political organizations have emerged distinguished by the different kinds of constitutions that define responsibilities and privileges. Among these are Monarchy, a system of government in which the King is considered an excellent man who surpasses all citizens with knowledge and virtue; there is also Aristocracy, a government by a few men of virtue. We also have Oligarchy, a government by unscrupulous rich men who have no regard for the poor. Different from these political systems is democracy. However, when African traditional political systems are discussed, they are often described as monarchical or aristocratic as in the case of the Western part of Nigeria, or republican as the Eastern part of Nigeria has been classified. This is a perspective that is evident in Arogbofa (2007) who argues that the traditional political systems of Africa had no place for democracy.

European and African political thinkers see democracy as a system of government that began in Greece and was imported from Europe to Africa. This chapter argues contrary to the opinion of Arogbofa and his 'likeminds' that democracy is a cherished African value, which existed in pre-colonial Africa as a pattern of administration. It further argues that democracy was already in Africa even before the encounter of Africa with the West, and thus, that Africa is not a passive recipient of democracy. To substantiate this thought, the political systems of administration obtainable among the traditional Yoruba, particularly, the Oyo Empire, and Igbo of Eastern Nigeria would be studied for the unveiling of the democratic structures of the Yoruba and Igbo political-cultural heritage.

Understanding Democracy

The word democracy comes from two Greek words: *demos*, which means people and *kratein*, which means to rule. Put together in Greek, it means the power of the people. It is in this regard that Lincoln (cited by Salami 2004) described democracy as "the government of the people, by the people and for the people under the rule of law" (p. 316). In the contention of Gyekye (1997) and Busia (1975), the concept "the people" points to the power of the people to choose who to rule them in accordance with the general good of the society, and that they set up, by themselves, the constitutional rules, principles and procedures of governance.

Carter (1978) describes democracy as a system that is altered by time and experience, always changing, infinite in its

variety, sometimes it is turbulent, however, still valuable since it has been tested by adversity. As a political structure, Salami (2006) avers that democracy emphasizes the sharing of power among people of various categories. For Brecht (1959), it emphasizes that values should not be forced upon any people against their will, and stipulates liberty, separation of power and the sovereignty of the people. Thus, Sabine (1973) thinks that it must involve mutual concession and compromise as a way of arriving at decisions. From these perspectives, Chidili (2012) posits that three salient points are noticeable from the definition of democracy:

 a. that democratic government is not monotypic but diverse in nature;
 b. that even in its diversity, it is changing;
 c. it is strictly based on the rule of law.

Thus, Chidili concludes that the mutability of the capacity of democracy provides elbowroom for it to be an adaptable system of governance that can exist anywhere in the world, including Africa.

The Yoruba Traditional Political Organization

The Yoruba traditional political organization that would be under consideration in this section is the Oyo Empire. As a kingdom, it reached its heights in the 18th century, however, was founded in the 14th century about 1300 BC by Oduduwa who settled in Ille Ife during the 14th century. According to Smith (1969), Ife was considered the religious center of the world and the site where human beings were

first created. Before his arrival, Ayittey (2006 and 2012) avers that there were already about 13 semi-autonomous settlements in Ille Ife who had organized themselves into a loose confederacy. When Oduduwa came, he subjugated them and imposed his authority over them. As of the time, it was the largest empire in Yoruba land to exist and the most important and authoritative of all the early Yoruba principalities. Because of the wealth of military skill, the authority of the Oyo Empire was felt beyond the Yoruba states to as far as the Fon of the then Dahomey Kingdom. By the 19th century, the Oyo Empire began to collapse as a result of administrative disagreements among the leaders. Gradually the provinces began to revolt as the centre lost its ability to govern. By 1888 it had collapsed and became a Protectorate of Great Britain.

a. **The Alaafin:** In the Oyo Empire, the *Alaafin* was the sole voice of authority, however, with limitations. Before the *Alaafin* can take any valid decision, he must consult with the *Oyomesi*. He had a large amount of ritual restrictions which limited his authority. For instance, he was not allowed to leave the palace except during important festivals. This made it easy for those who were vying for his position to take over power. The *Alaafin* was also a spiritual leader who was regarded as a representative from the spirit world. He was, therefore, required to devote himself to the worship of *Orisa*. Within the palace, he worked together with the *Ona Efa*, the Empire's Chief Justice, the *Otun Efa*, the Priest of *Shango* Shrine, and *Osi Efa*, the minister of Finance.

b. **The *Oyomesi*:** The *Oyomesi* consists of a council of the heads of the seven non-royal wards of the city of Oyo, though sometimes six in number. They guided the king's decisions in many issues, such as military action, religious festivals, etc., and had the responsibility of checking the excessive powers of the *Alaafin*. The leader of the *Oyomesi* was called *Bashorun*, the authority he controlled rivaled that of the *Alaafin*. He was the Commander-in-Chief of the army of the Empire and presided at religious festivals, thus, giving him a religious and militaristic edge over the *Alaafin*. One of the most important religious celebrations of the Empire was the *Orun*, and during this ceremony, the *Bashorun* had the power to depose the *Alaafin* by causing him to commit suicide. Usually the *Bashorun* would present the *Alaafin* with a calabash which signifies that the *Oyomesi* and the ancestors have lost confidence in him. During battles, the position of the *Bashorun* became higher and more important than that of the *Alaafin*; he sat in a stool that stood higher than that of the *Alaafin*.

c. **The *Ogboni*:** the *Ogboni* is another important political structure in the then Oyo Empire, and in fact the second council in the Oyo Empire that helped in checks and balances of authority. The council was composed of the representative of the various lineages, and was headed by the *Olowu*. They had the primary responsibility of checking the excessive powers of the *Bashorun*. Before a person can be appointed as a *Bashorun*, the *Ogboni* must issue their approval.

d. ***Are-Ona-Kakanfo*:** This was the military commander of the Empire who was never expected to lose any war. If he loses a war, he had the options of either committing suicide or going into exile. He was responsible to the *Alaafin* and *Bashorun*. He was appointed by the *Alaafin*, however, promoted by the Oyomesi.

e. **The *Aremo*:** The *Aremo* was the crown prince. While the *Alaafin* remained in the palace as the king of the palace, the *Aremo*, who is the first son of the king was for the general public. The *Aremo* could move out of the palace as he had no ritual restrictions on his movements. During the early stages of the empire, when an *Alaafin* died, the *Aremo* took over, however, it was later discovered that some *Aremo* killed their father in order to ascend the throne. A law was, therefore, made that when an *Alaafin* dies, the *Aremo* should commit suicide.

f. **The *Babalawo*:** The *Babalawo* was the spiritual guide of the *Alaafin*. Although he was not required to be part of the council, he was very often consulted to provide spiritual advice. His relevance is based on the belief that he was in direct communication with the spirits, and thus, his advice is considered divine knowledge.

The Oyo Empire survived on this political system until its collapse and the advent of Europeans.

The Igbo Traditional Political Organization

Two theories have emerged in response to the question of the origin of the Igbo. There is, the 'Northern Centre Theory' which, according to Onwuejeogwu (1987) posits that the Igbo migrated from five northern centre areas, namely: the Semetic Centre of the Near and Far East, the Hermatic Centre around Egypt and Northern Africa, the Western Sahara, the Chadian Centre and the Nok Centre. The second historical hypothesis is the 'Centre Theory of Igbo Heartland'. According to Isichei (1976), the early migrations of the proto-Igbo originated from the areas termed as the Igbo heartland, such as: Owerri, Okigwe, Orlu and Awka divisions.

According to Shaw (1969), Afigbo (1981), Anozie (2002) and Chikwendu (2002), the dispersal of the Igbo from the Igbo heartland dates back to the time between 2555 BC and 800 AD. Whatever theory is adopted, Ajaegbo (2014) avers that as the Igbo dispersed and permanent settlements developed, communal living led to the emergence of economic, social and political institutions. From these settlements emerged leaders who became centers of authority, as social groups developed, effective administrative systems emerged to regulate social relations. This was founded on egalitarian and democratic structures.

The political organization was constituted by different levels of autonomous democratic governments which exercised political, social and economic control over the lives of the people. These autonomous democratic governments

include the Nuclear Family, the Patrilineage (Umunna), the Maximal Lineage and the Village-Group Assembly.

a. **The Nuclear Family** was the bedrock of social and political organization, referred to as *ezi na uno*. It consisted of a man, his wives, his married and unmarried sons, unmarried daughters and the servants or slaves, if any. The Father was the leader of the household and was in possession of the family *ofo*, which is the symbol of authority, justice, law and uprightness. The Father was responsible for directing the affairs of the family, however, it was done in consultation with his senior sons and wives.

b. **The Patrilineage or Extended Family** is the next unit of political organization after the nuclear family, which is referred to as the *Umunna*. It is composed of a number of families that have a common eponymous father. Uchendu (1965) defines the *Ununna* as "a territorial kin-based unit which subdivides into compounds *(ezi obi)*" (p. 40). The head of this political unit was the oldest male member of the extended family also known as the *di-okpara* and had the *ofo* of the extended family in his possession. This according to Ogbukagu (1997) is based on the gerontocratic nature of the Igbo system of governance, even though Isichei (1976) avers that the important place given to elders does not mean that all elders have equal rights to speak. According to Opone (2012), the leader is usually a grandfather or great grandfather. In the

Disciplines of African Philosophy

contention of Olisa (2002) and Nwosu (2002), the *di-okpara* presided over meetings, sacrifices, issues of inheritance, settlement of dispute among members of the extended family, marriage, allocation of lands and the representation of the family with other extended families. In decision making, the *di-okpara* worked in consultation with the other heads of the extended family who constituted the extended family assembly. Decisions were arrived at through dialogue, consensus *(nkwekolita)*, compromise, cooperation and consultation *(Igba Izu)*.

c. **The Maximal Lineage** is the next biggest socio-political organization after the extended family. This is referred to as *Idumu* in Igbo, which means quarter. It is made up of a number of extended families who are linked by a common putative ancestor. This major lineage is headed by the oldest male among them. He holds the *ofo* of the major lineage and presided at functions concerning the major lineage and was considered as a sacred person with taboos and rituals accompanying the violation of his authority. In his exercise of authority over the major lineage, Ajaegbo (2014) avers that he worked in consultation with a large assembly comprising senior household men, titled men, priests, men of honour, intelligence and wealth etc.

d. **The Village-Group Assembly** was the biggest socio-political group referred to as *ogbe* (village). Ajaegbo (2014) observes that it was composed of a number of major lineages who are descended from

a common ancestor or different putative ancestors. Onwuejeogwu (1972) refers to the *ogbe* as federation of autonomous settlements, and by Nzimiro (1972) as wards. The assembly was the highest authority with its members being senior males of households, professional hunters, priests, honourable and wealthy men, warriors, titled men, medicine men, etc. The leader of this assembly varied from one village to another, in some it was headed by the council of elders: a group of wise, knowledgeable, courageous and transparent men, Maquet (1972) refers to their authority as "a collegial authority exercised by the chiefs of the various lineages living in the village" (p. 57). In some, the oldest member of the council of elders referred to as the *diokpa*, and in this case, he becomes the custodian of the *ofo*. The supreme head of the assembly took decisions in consultation with the constituent members of the village assembly. Consultation, consensus and compromise were necessary elements in resolving issues and decision making. The village square (*ama nzuko ora*), usually a common place, was the arena of assembly.

Democratic Values in African Political Heritage

In the political administrations of the Yoruba and Igbo traditional political systems, there were strong systems of checks and balances, and this is consistent with most socio-political structures of ancient Africa. Although the *Alaafins*

and the Igbo heads wielded much power, they were not absolute leaders. There was elaborate organization of palace officials or chiefs especially among the Yoruba. For instance, while the *Alaafins* had the *Oyomesi*s to regulate their power, the *Oyomesi*s were regulated by the *Ogboni* council who were backed by the authority of religion.

In the Igbo political system, particularly, during decision making, it is not the oldest man that imposes his will upon the people, but decisions are reached through discursions, consultations, dialogue and compromise which might take the shape of imposing the will of the majority on the minority and this reveals the democratic value that does not see the community as a constellation of impersonal forces but rather a complex of human beings and human interests that upholds the ethos of resolving human antagonistic interests through negotiation. According to Wirendu (1995):

This should not be confused with decision-making on the principle of the supreme right of the majority. In the case under discussion the majority prevails not over, but upon, the minority- they prevail upon them to accept the proposal in question, not just to live with it, which is rather the basic plight of minorities under majoritarian democracy. In a consensus system the voluntary acquiescence of the minority with respect to a given issue would normally be necessary for the adoption of a decision. In the rare case of an intractable division, a majority vote might be used to break the impasse. But the success of a system must be judged by the rarity of such predicaments in the working of the decision-making bodies of the state. (p. 62).

During decision making, the perspective of every lineage in the village is represented in the presence and contributions of their representatives. It can be compared to the House of Representatives, a structure that provides the space for the genuine meeting of minds for the interchanging of opinion and understanding. Decisions arrived at at this council was not enforced through policing, but through what Maquet (1992) calls 'collective pressure'. At the centre of these African traditional political structures was the rule of law.

The choice of the king or leader in both the Yoruba and Igbo traditional societies, or access to the throne was based on equal opportunities: the aspirants were treated as equal candidates and were subjected to the same rules and treatment. For instance, among the Yoruba, Osae and Nwabara (1980) aver that the candidates for the position of *Alaafin* came from different royal families already marked from which contestants can emerge for the final choice by the *Oyomesi* and the *Ifa* oracle. This is done according to laid down rules agreed upon by the people. Even when contestation arises at the end of the choice, Al-Yasha (2003) observes that the choice is not imposed on the people; there were ritual checks and balances to resolve issues of contestation of succession to the throne.

Conclusion

What we find in these traditional democracies, is a balance of autocratic dictatorship and popular democracy. It could be referred to as a participatory democracy. These democratic traditions were however, disrupted, undermined

and devastated by the colonial political infrastructure. The strike at African indigenous institutions affected virtually all aspects of the African life. The religio-social formations that ensured democracy, such as the *ozo* title holders, elders, deities, masquerades, etc., were disregarded, disorganized and divested of their political roles. When the Colonial authority came, traditional leaders were made warrant chiefs and subjected to the authority and supervision of British political officers. Thus, making them no longer accountable to their people but to the British political officer who appointed them. The result is that they betrayed their own people and gradually THINGS FELL APART.

References

Afigbo, A.E. (1981). *Ropes of sand: Studies in Igbo history and culture.* London: Oxford University Press.

Ajaegbo, D. I. (2014). African democratic heritage: A historical case study of the Igbo of Nigeria. *Journal of Humanities and Social Science. 19. 4.* 17-23.

Al-Yasha, W. (2003). On the subject of kings and queens: Traditional African leadership and the diaspora imagisociety. *African Studies Quarterly. 6. 4.* 1-6.

Arogbofa (2007, October 7). Travails of democracy in Nigeria's democracy. *Sunday Mirror.* 48.

Ayittey, G. (2006). *Indigenous African institutions.* New York: International Publishers.

Ayittey, G. (2012). *The Oyo empire.* Retrieved 20th January 2015 from https://seunfakze.wordpress.com/2012/02/09/theoyoempire.

Brecht, A. (1959). *Political theory: The foundations of twentieth-century political thought*. Princeton: Princeton University Press.

Busia, K. A. (1975). The ingredients of democracy. In G. Mutiso and S. W. Rohio (Eds.). *Readings in African political thought* (pp. 453-455). London: Heinemann.

Carter, J. (1978). *Speech to the parliament of India*. June, 2.

Chidili, B. (2012). African traditional values and sustenance of democracy. In E. O. Ezenweke and A. I. Kanu (Eds.). *Issues in African traditional religion and philosophy* (pp. 103-120). Nigeria: Augustinian Publications.

Chikwendu, V.E. (2002). Archaeology of Igboland: The later prehistory. In G.E.K. Ofomata (Ed). *A survey of the Igbo nation*. Lagos: Africana Publishers Limited.

Gyekye, K. (1997). *Tradition and modernity: Philosophical reflections on the African experience*. Oxford: Oxford University Press.

Isichei, E. (1976). *A history of the Igbo people*. London: Macmillan.

Maquet, J. (1972). *Africanity*. New York: Oxford University Press.

Nwosu, A. N. (2002). Politics and administration in the Igbo traditional society. In G.E.K. Ofomata (Ed). A survey of the Igbo nation. Lagos: Africana Publishers Limited.

Nzimiro, I. (1972). *Studies in Igbo political systems. Chieftaincy and politics in four Niger states*. London: Frank Cass.

Ogbukagu, I. N. (1997). *Traditional Igbo beliefs and practices*. Nigeria: Novelty Industries Enterprises.

Olisa, M. (2002). Igbo traditional political system. In G.E.K. Ofomata (Ed.) A survey of the Igbo nation. Lagos: Africana Publishers Ltd.

Onwuejeogwu, M. A. (1972). *The traditional political system of Ibuzo.* Nri: Odinam Museum.

Onwuejeogwu, M. A. (1987). *Evolutionary trends in the history of the development of the Igbo civilization in the culture theatre of Igbo land in Southern Nigeria.* A paper presented during the Ohiajioku Lecture, Owerri.

Opone, P. O. (2012). Traditional socio-political organizations of the Enuani Igbo of South Central Nigeria. *Study Tribes Tribals. 10. 1.* 57-66.

Osae, T. A. and Nwabara, S. N. (1980). *A short history of West Africa, AD 1000-1800.* London: Hodder and Stoughton.

Sabine, G. H. (1973). *A history of political theory.* New Delhi: Oxford University Press.

Salami, Y. K. (2004). Yoruba proverbs and democratic ethos. *Proverbium Yearbook of Intersociety Proverb Scholarship. 21.* 315-328.

Salami, Y. K. (2006). The democratic structure of the Yoruba political-cultural heritage. *The Journal of Pan African Studies. 1. 6.* 67-78.

Shaw, T. (1969). Igbo-ukwu, eastern Nigeria. In T. Shaw (Ed.) Nigerian prehistory and archaeology. Ibadan: Ibadan University Press.

Smith, R. S. (1969). *Kingdoms of the Yoruba.* London: Methuen and Co. Ltd.

Uchendu, V. C. (1965). *The Igbo of South East Nigeria.* New York: Holt Rinehart and Winston.

Wirendu, K. (1995). *Conceptual decolonization in African philosophy.* Ibadan: Hope.

TOWARDS AN AFRICAN PHILOSOPHY OF EDUCATION

Introduction

Education, the most ancient concern of mankind, does not lend itself to any single definition. It has the growing quality of a living organism and seamless web. This would first imply that it has life; secondly, it constantly adapts itself to new and changing circumstances, according to time and place, however, maintaining some permanent features or attributes. It adapts itself to new circumstances and demands. While there are changes according to time, there is a presence of permanence which unites the universal experience of education; and while there is plurality according to place, there is unity which identifies and authenticates the educative experience. It is from the above perspective that one can talk about an African indigenous education. What makes it distinctive from others are domicile in the African traditional cultural heritage.

Although various African scholars have written on African traditional education (Majesan 1967, Fafunwa 1974, Snelson 2974, Tiberondwa 1978, Stambach and Semali 1997, Adeyemi and Adeyinka 2002, Okoro 2010, Ndofirepi and Ndofirepi 2012), the burden of this piece is to explore the meaning and nature of African indigenous education within the context of the nature of the human person as a basis for education. It would further attend to questions that boarder on the purpose and philosophical principles of African traditional education.

The Nature and Meaning of Education

Education, etymologically, is derived from the Latin words: *educare*- which means 'to bring up', 'to rear', 'to guide', 'to direct'; from the foregoing, education becomes the process of bringing up children by the adults of the society; and *educere*- which means 'to draw out', 'to lead out', 'to raise up', 'to bring up', 'rear a child'. From this root, education for Adeyemi and Adeyinka (2002), becomes the "slow and skilful process of extracting the latent potentialities of comprehension and dedication, in contradiction with indoctrination" (p. 225). Although the concept, education as observed by Balogun (2008) has been exposed to different and sometimes contradictory interpretations, generally it can be understood as a process of development of the natured and nurtured potentialities of an individual to help him or her fit into the society, in which he or she is a full-fledged member. It is an activity of transmission and a fundamental factor of social change. As a wide frontier, it embraces not just the deliberate processes of school and college, but also

the in-deliberate and accidental experiences that a person encounters. Thus, education is not coterminous with schools and colleges. It is rather a process that continues throughout life: it is a process, a system, an enterprise, a discipline and a way of life.

The Meaning of African Traditional Education

For a better appreciation of the concept *African Traditional Education*, there is the need to analyze the simple words that constitute the compound word. The first concept is **African**: it speaks of a relation to, or characteristic of Africa, or its people, language, culture, geography, etc. **Traditional**: this concept has been contended by scholars, since it is suggestive of that which is ancient, and therefore, no longer practiced. In this work, it is used to denote indigenous practices and beliefs, facts, customs, often handed down from generation to generation, unwritten or written. As such, it combines the idea of the past, the present and the future. It is in this regard that the Longman Dictionary of Contemporary English (1990) defines tradition as "The passing down of opinion beliefs, practices, customs, etc., from past to present, especially by word of mouth or practice" (p. 1174).

African traditional education refers to the type of education that was obtainable in Africa before the advent of the West as colonial masters and missionaries, which Boateng (1983) avers prepared them for their responsibilities as adults in their communities. It was a method of education that was based on the African cultural heritage, with the family as the first school

and the parents the first teachers of the child. Gradually, the uncles and community get involved in the education of the child. Just as we have Greek education, Western education etc, Africans also had a method of education defined by the African worldview. It was a native, locally developed lifelong process of learning, with well defined goals, structures, content and methods, through which cultural values, skills, norms and heritage were transmitted by the older and more experienced members of society from one generation to another to help the individuals to be integrated into the society. At the end of such education, it is true that graduants never wrote final year examinations or were not awarded certificates; however, they graduated ceremoniously and were considered graduates by the society, not because they had papers to show, but because they were able to do what they have graduated in.

The Human Person as the Ontological Foundation of African Indigenous Education

The quality, method and parameters of education employed by any particular people are fundamentally determined by the people's concept of the human person. In African ontology, its cosmology is heavily anthropocentric. That is, the human person is at the centre of the universe. Mbiti (1969), therefore, asserts that "Man is at the very centre of existence and African people see everything else in its relation to this central position of man… it is as if God exists for the sake of man" (p. 92). Corroborating with Mbiti, Metuh (1985), stresses that "Everything else in African

worldview seems to get its bearing and significance from the position, meaning and end of man" (p. 109). The idea of God, divinities, ancestors, rituals, sacrifices etc., are only useful to the extent that they serve the needs of the human person. It is in this regard that Udechukwu (2012) argues that man, in African cosmology, has been given a high and prestigious position.

However, the human person is a being that has its origin and finality in the Supreme Being. This implies that the human person in the African universe is best understood in his relationship with God his creator, to whom, from the Igbo perspective, he is ontologically linked with through his *chi*, the spark or emanation of God in each person. The human person in African worldview has a purpose and mission to fulfill; he/she comes into the world as a force amidst forces and interacting with forces. Good status, good health and prosperity are signs of the wellbeing of a person's life-force, and man struggles to preserve it through an appropriate relationship with the spiritual forces around him. The goal of every human person, according to Kanu (2015a) is to achieve his *akara chi,* the destiny imprinted on his palm by his creator. In the search for ones destiny, Kanu (2015b) avers that the human person is not just an individual person, but one born into a community whose survival and purpose are linked with others.

The human person has been given a high and prestigious place in the economy of creation. He relates with God, the divinities and spirits and tries to maintain an ontological order in the universe. This would require the development

Disciplines of African Philosophy

and maintenance of moral character on the part of the human person. To be at peace with fellow human beings and God, there are several elaborate taboos, modest limits of order in the political, economic and social arenas. These values are transmitted to the human person through a process referred to as education, received from the family, the community and society at large. The nature of the human person in African ontology is the basis of education. This explains why the family, the community and society work hard to educate the human person.

The Purpose of African Traditional Education

The aim of education in traditional African society is multilateral. These aims could be articulated as follows:

1. To prepare the young for life. Education in Africa is always for a particular purpose. There is nothing like a purposeless education.
2. To help people to realize themselves. Self-realization is at the heart of African indigenous education. The first thing a child is taught is who he or she is, where he or she has come from, the heroes that have come from his clan, etc. self-realization helps him or her to know how to comport the self.
3. To help people to relate with others in an atmosphere of mutual understanding. Life in African traditional society is relationship. To be is to relate, to cease to relate is to move towards annihilation. It is in this regard that individuals are taught to relate with one another.

4. To inculcate the spirit of self-reliance, industry, versatility and self-discipline. In African traditional society, people are trained to be self-reliant. They do not wait for the government to give them employment. They rather work hard to contribute to the general society.
5. To make the educated aware of his or her responsibilities and privileges. These responsibilities and privileges go with status. There is no status in traditional African societies without responsibilities and privileges. Thus, before a person attains that status- married, etc, the person in question is taught the responsibilities and privileges that go with them.
6. To develop a person's latent physical skills.
7. To develop the character of a person.
8. To help a person to understand, appreciate and promote the cultural heritage of the community or society.

The Philosophical Canons of African Traditional Education

Ocitti (1971) enumerated five canons or philosophical principles that are vital to Africa indigenous education. They provide a foundational structure on which Africa indigenous education was built. These canons include preparationism, functionalism, communalism, perenialism and holisticism.

a. **Preparationism**
This principle asserts that people were trained for the purpose of equipping them with a particular skill for the fulfilment of their particular roles

in the family or society. Knowledge conferred was always for a particular purpose- skill for an awaited responsibility. For instance, the boys were trained for the purpose of fulfilling male roles in the society. Boys, on the one hand, were trained to be hunters, farmers, carving, canoe making, tinsmithery, palm wine tappers, pot making, clay working, fishermen, warriors, blacksmith, butchers, leaders, dancing, etc. Girls, on the other hand, were equipped with skills for feminine roles like cooking, home-keeping, sieving, cloth making, grinding, pounding, dancing, caring for a baby, etc. because of this particular orientation, boys and girls were trained to be self-reliant, responsible and obliged to the community.

b. Functionalism

According to this principle, African traditional education is practical and participatory in nature. The pupil learns through working with or observing the master. For instance, young men learnt the art of farming by following their fathers to the farm and learning how the land is tilled, the crops planted, the farm weeded and crops harvested. As they learn they begin to participate in these activities. Once he or she becomes a student, the person begins to participate in what is learnt. For instance, when a boy wants to be a medicine man and he is admitted, he learns by going with the master into the bush to get the herbs needed, to fetch water for him, to clean up the shrine, to grind the medicine, he watches

him call upon the gods, he listens to him invoking the gods, he learns the words, the gestures etc. as the master does it, he follows in his step. In this way, the student becomes fully integrated into the occupation even before he graduates. Even before he graduates, he has begun to practice. Education, therefore, is always practical, not theoretical, but with a practical concrete context.

c. **Communalism**

In African traditional education, the responsibility of teaching was not solely the responsibility of the parents of the child. This is based on the fact that the child is not individually owned. There is an Igbo adage that says: "Nwa bu nwa oha" (A child is for everyone). The parents, family, the community and society are all involved in the training of a child. In the absence of a father, an uncle can teach or correct a child. When a child does something wrong like refusing to join his age grade in sweeping the village square, eating in the morning without washing the face or chewing stick, refusing to surrender his or her chair when an elder enters, etc., a fellow villager can correct or scold the child. This is very important as one thing done by another could have adverse consequences on another. Teaching another person or correcting the other is a good which one does to himself or herself; and to leave the person without correcting or teaching is do oneself harm. This makes teaching a collective responsibility. More so, by communalism, it is also meant that education

was community oriented, that is, geared towards the solving of community problems. The instructional activities were geared towards the social life of the community, so as to prepare the pupil to fit into their community.

d. Perennialism

Generally, perennialism as a principle believes that in our world of upheavals, and uncertainty, it is beneficial to stick to certain absolute principles. It sees education as a way of preparing the child to become acquainted with the finest achievements of his cultural heritage, to become aware of the values of his heritage. When African traditional education is said to be the perennial, it simply implies that African indigenous education was conservative and prepared the young to always maintain the *status quo,* that is, to maintain the cultural heritage that has been handed down from one generation to the next. From this, we see why it was necessary in traditional African societies to have taboos. It is in this regard that Mushi (2009) maintains that "criticism about what they were taught was discouraged and knowledge was not to be questioned. Questions seeking clarification on aspects not clearly understood were encouraged" (p. 39).

e. Holisticism

In the traditional educational system in Africa people were trained to be were productive in all areas. It was a multiple kind of education. Although a person is

a trained hunter, he can as well farm, butcher the game caught, preserve the meat or market it. The fact that a person is a trained dancer or wrestler does not mean that he wouldn't be able to farm, build his house or hunt. This is the same with girls. They could cook well, dance well, take care of the home and even help another woman give birth.

People were trained not just in regard to skill acquisition, Emenanjo and Ogbalu (1982) observes that people were trained in different areas of traditional education in order to produce educated individuals. No domain of education was left out. Firstly, people were trained to be educated physically- this concerns activities that aid the development of the physical body; secondly, morally- the educated must lay restraints on his or her boundless urges and impulses; thirdly, character training- this is the basis of the African commitment to education. A positive change in a person during education process is very fundamental in Africa. Fourth, intellectually- which has got to do with a person's ability to integrate observed experiences, conceptualize and size a situation; fifth, vocationally- this focuses on job-oriented education, which involves the acquisition of skills.

Conclusion

The foregoing study on African traditional education reveals that it was a model of education that ensured that everyone

who went through it was employed- it was practical and tended towards self-reliance. It was also a system of education that preserved the socio-cultural structures of society. It instilled national pride in the learner and inculcated in him a communal spirit rather than an individualistic attitude. However, it also suffered some limitations which include: its curriculum being confined only to the categories common to a particular clan or society; in the bid to preserve the status quo, criticism was not entertained- knowledge was passed on from one generation to another without critical appraisal; it was dominated by oral tradition, making it difficult to preserve accumulated knowledge and skills.

Added to these is the secrecy that surrounded the content of traditional education. In the midst of these weaknesses, however, African traditional education has great relevance or implications for modern African education. Its value that needs to be imbibed is that of self-reliance- many people in our time acquire certificates but do not know what to do with them for themselves and for the society. Another area of interest is that the modern day education needs to borrow from the traditional by developing problem solving educational curriculum rather than abstract models that become irrelevant in the face of concrete challenges. More so, the idea of Universal Basic Education introduced by many governments in Africa under various names can become more successful when the modern society goes back to the traditional model to see that it made sure that the entire society was educated. With the prevalence of corruption in Africa, there is the need to imbibe the multilateral model that produced both skilled and honest people.

References

Adeyemi, M. A. & Adeyinka, A. A. (2002). Some key issues in African traditional education. *Mcgill Journal of education. 37. 2.* 223-240.

Balogun, O. A. (2008). The idea of an educated person in contemporary African thought. *The Journal of Pan-African Studies. 2. 3.* 117-128.

Boateng, F. (1983). African traditional education: A method of disseminating cultural values. *Journal of Black Studies. 13. 3.* 321-336.

Emenanjo, E. N. & Ogbalu, F. C. (1982). *Igbo language and culture.* Ibadan: University Press.

Fafunwa, A. B. (1974). *History of education in Nigeria.* London: George Allen and Unwin Ltd.

Kanu, A. I. (2015a). *African philosophy: An ontologico-existential hermeneutic approach to classical and contemporary issues.* Augustinian Publications: Nigeria.

Kanu, A. I. (2015b). *A hermeneutic approach to African philosophy, theology and religion.* Augustinian Publications: Nigeria.

Majasan, J. A. (1974). *Yoruba education: Its principles, practices and relevance to current development.* Unpublished Ph.D. Thesis, University of Ibadan.

Mbiti, J., *African religions and philosophy.* Nairobi: East African Educational, 1969.

Metuh, E. I., *African religions in Western conceptual schemes: The problem of interpretation.* Jos: Imco, 1985.

Muchi, P. A. K. (2009). *History of education in Tanzania.* Dar-es-Salaam: Dar-es-Salaam University Press.

Ndofirepi, A. P. & Ndofirepi, E. S. (2012). Education or education in traditional African societies: A philosophical insight. *Stud Tribes and Tribals. 10. 1.* 13-28.

Okoro, K. N. (2010). African traditional education: A viable alternative for peace building process in modern Africa. *Journal of alternative perspectives in social sciences. 2. 1.* 136-159.

Semali, L. & Stambach A. (1997). Cultural identity in an African context: Indigenous education and curriculum in East Africa. *Folklore Forum 28. 1.* 3-27.

Snelson, P. (1974). *Educational development in Northern Rhodesia, 1883-1945.* Lusaka: Kenneth Kaunda Foundation.

Tiberondwa, A. K. (1978). *Missionary teaches as agents of colonialism: A study of their activities in Uganda, 1877-1925.* Lusaka: Kenneth Kaunda Foundation.

Udechukwu, G. (2012). Igbo traditional education and good governance. In A. B. C. Chiegboka et al (Eds.). *The humanities and good government (pp. 812-819).* Anambra: Rex Charles and Patrick.

TOWARDS AN AFRICAN LOGIC

Introduction

In the area of philosophy, there are various themes that have constituted problems for reflection and analysis by philosophers; however, one of the major concerns in philosophy is the problem of the meaning of philosophy itself. This is evident in the historical evolution of philosophy. For the Ionian School of Philosophy, philosophy would be nothing more than asking and offering rational explanations of the universe. For the sophists, it would be questioning the foundations of traditional religion, morality and the gods from a subjective perspective. In Socrates, philosophy is acquiring knowledge through questions and answers; thus would involve a process of asking questions and questioning answers until answers are unquestionable and questions unanswerable. For the Cynics and Cyreniacs, philosophy would be a path to self-knowledge and thus self-sufficiency. Patristic and Early Medieval philosophers would understand philosophy as the handmaid of theology: an instrument for clarifying theological concepts. Descartes would understand

Disciplines of African Philosophy

philosophy as a search for the certainty of knowledge. The variety of perspectives as to what constitutes philosophy can continue even to the contemporary era.

It is, therefore, not surprising that Jasper (1953) avers that "What philosophy is and what its value is, is contentious" (p. 9). In the contention of Geisler and Feinberg (1980), "... the central and most fundamental philosophical question is the nature of philosophy itself" (p. 13). This, contention, according to Asouzu (2011) is at the root of most controversies and disagreements in the department of philosophy. This notwithstanding, philosophy is from the Greek words: φιλο (*philo*) meaning *love* and σοφια (*sophia*) meaning *wisdom*. Brought together, it means 'the love of wisdom'. The concept is a neologism attributed to Pythagoras. Thus, he presents philosophy as a high and supreme achievement of man, and philosophers as aspirants to or proponents of wisdom. According to Maziarz (1987), in this relatively strict sense, philosophy implies both the process of questioning and the results of this interrogation as embodied in a personal or public enterprise of value to mankind.

As an academic discipline, philosophy exercises the principles of reason and logic in an attempt to understand reality and answer fundamental questions about knowledge, life, morality and human nature. Thus, Teichmann and Katherine (1999) and Quinton (1995) would agree that philosophy is a rational critical thinking, of a more or less systematic kind about the general nature of the world, the justification of belief and the conduct of life (p. 666). The idea of an African philosophy does not in any way change the concerns of

philosophy but only particularizes it to the African context that philosophy might be relevant to the people of Africa- it can be regarded as an African department of the general concerns of the faculty of philosophy; whether Western or African philosophy, logic is an indispensable ingredient that drives the philosophical process to its conclusion.

Can there be an African Philosophy without an African Logic?

The foregone has established that for philosophy to retain the identity of philosophy, it must have the basic element of logic to maintain the philosophical structure. This would mean that that which bears the name 'philosophy' should have logic in it. As regards African philosophy, the question of whether there is an African philosophy or not has been overtaken, captured and conquered by African philosophers. Thus, Makinde in 2010 published the work: *African Philosophy: The Demise of a Controversy;* even long before Makinde, Innocent Onyewuenyi in 1993 had written a book on *The African Origin of Greek Philosophy: An Exercise in Afrocentrism,* thus, dating African philosophy before Western philosophy and, in fact, making her the springboard of Western philosophy. Students, from B.Sc to Ph.D cadres are defending their Theses and Dissertations respectively in the area of African philosophy. Conferences are organized in different parts of the world on African philosophy, with many emerging academic associations in Africa identifying with African philosophy. In fact, African philosophy has become a burgeoning field of scholarly investigation. Amidst great challenges, African philosophy has, with a swaggering

Disciplines of African Philosophy

gait, migrated from bedside consultations to wider social consultations that privilege discourses about everyday African life issues. It is studied in many universities in Africa, and has, in fact, moved beyond the shores of Africa, finding its way into the curriculum of many universities in Europe and America, where it is taught by both African and non-African professors.

Having established the existence of African philosophy, it would be illogical to ask the question: is there an African logic? The idea of an African logic is the implication of domesticating or inculturating philosophy. It is the African logic that gives birth to the philosophy that is distinctively African. There is a close tie between philosophy and logic, and in fact, that it is logic that makes philosophy, and secondly, if it is accepted that philosophy is culture bound, accounting for the emergence of English, German, Indian, Chinese philosophies, it then means that logic is culture bound as well. This is the basis for an argument for an African logic. If there is no African logic that is determined by the African worldview, then African philosophy would be a caricature of contextual philosophy, and in fact would be out for a western-generated approach to attending to human issues. This does not in any way mean that the logic that is African would lose its universal character- it is still the standard universal logic, but with an African touch. However, as we go further on this issue, it might be necessary to first understand the meaning and nature of logic.

The Meaning and Nature of African Logic

Etymologically, logic is from the Greek word 'logos', which is translated into English as the 'word'. In Greek it stands for divine intelligence, and the underlining structure of reality or purpose. This explains why it is use for God in the Gospel of John who is referred to as "the Word". While this etymological definition does not bring out the function of logic, it gives an insight into the general understanding of logic as the principle of correct reasoning. However, Nyarwath (2010) defines logic as "a branch of philosophy that studies reasoning. It deals with the operations of right reasoning. It studies principles and rules of reasoning with the main aim of distinguishing between correct and incorrect, good and bad reasoning" (p. 1). Thus, Ejikemeuwa (2015), Copi (1982) and Aja (2008) assert that the art of sound, correct and critical reasoning is in the domain of logic. Logic, according to Bello (2000) adds that logic removes ambiguities and obscurities from human discourse. Logic brings out truth from falsity, consistency from inconsistency, orderliness from disorder, valid argument from invalid argument.

Aristotle refers to logic as an organon or foundation of knowledge. It belongs to the arena of logic to judge inferences good or bad. According to Ochieng-Odhiambo (2009) "It attempts to answer such questions as: what is reasoning? What distinguishes good reasoning from bad reasoning, a good argument from a bad one, a valid argument from an invalid one? Are there any methods of principles to detect fallacies in reasoning, and if so, what are they?" Based on

these questions, he wrote further that "From these concerns of logic, it can be seen right away that logic is very, perhaps the most, important branch of philosophy. All branches of philosophy employ reasoning and whether the reasoning in these other branches are correct or not will depend upon whether they are in accord with the laws of logic. Hence a thorough grounding in logic is indeed most necessary" (p. 123).

By African logic, the focus is on the structure of African thought. Every culture and people has its own peculiar way of thinking or reasoning; and it is the African pattern of reasoning that has brought about the African logic. To speak of the diversity of logic, Momoh (1989) relates logic to human language which differs from culture to culture:

> In everyday usage of natural language we talk of a person as being logical if he is reasonable, sensible and intelligent; if he can unemotionally and critically evaluate evidence or a situation; if he can avoid contradictions, inconsistency and incoherence, or if he can hold a point of view argue for and from it, summon counter-examples and answer objections. (p. 174).

The adjective 'African' attached to the word 'Logic' speaks of the context or the locus of logicality. It is the application of reason to the world and culture of the African people. This is applied not just to written literatures but also to life experiences like: a bird crying in the night and a man dying in the morning. The logical connection of this kind is based

on the African principle expressed in the Igbo saying: *ife na-akpata ife* (something is caused by something); *odighi ihe gbaraka mee* (nothing happens without a reason); *nwata no nuzo na-agba egwu, odi nwa nnunu na aguru ya egwu no'hia* (a child who is dancing on the road, there is a bird singing for it in the bush), *You cannot see the rabbit in the afternoon in vain*. The Akan would say, "whenever the palm tree tilts it is because of what the earth has told it". Ejikemeuwa (2016) thinks that this type of conclusion is not reached after a single occurrence; it is based on several cases of witnessing a particular event over a period of time. From this experience, a logical connection is established.

Igwebuike and the Universality and Particularity of Logic

The idea of Igwebuike as the logic of African philosophy carries within it a dual but complementary understanding of logic. First it sees logic as a universal phenomenon. This is very important since logic is a fundamental ingredient of the human person whose thoughts and thinking are organized, analyzed and sustained by some intrinsic structures that make the way for a systematic conception of reality. This being the case, it can be said that logic is thus a necessary element of every culture. There is no culture that does not accommodate a good argument, especially as it concerns their conclusions. Whether in Africa or in Europe or in America or in Asia, if the assumption of an argument is true, the conclusion of the argument would always be true. For instance:

If Njoku is an African philosopher,
then Njoku is a great African thinker,
Njoku is an African philosopher,
Therefore, Njoku is a great African thinker

If Kanu is shorter than Emeka,
then Kanu should be taller than Usman
Kanu is taller than Emeka
Therefore, Kanu is taller than Usman

These are arguments that are logical and cannot be accepted in one culture and rejected in another culture. Their conclusions are all acceptable as their assumptions are true. Thus, the principles of logic are universal principles that could be generally applied to diverse situations, no matter where. They are, thus, topic-neutral and con-contingent, in the sense that they do not depend on any accidental features of the world.

By the particularity of logic, it is meant the context in which logic is applied. It speaks of the worldview which differs from one place to another; this bears on the universal application of logic. While logic is universal, it is clear knowledge that the cultural experiences of people is meaningful within the context of an organized language that points to a logical ability- it is a people's language that communicates their logical world. This establishes the nexus between culture or language and logic, and thus, between Igwebuike and the question of African logic.

Igwebuike as the Complementarity and Distinctiveness of African Logic

Igwebuike is the modality of being in African philosophy. It is from the Igbo composite word and metaphor *Igwebuike*, a combination of three words. Therefore, it can be employed as a word or used as a sentence: as a word, it is written as *Igwebuike*, and as a sentence, it is written as, *Igwe bu ike*, with the component words enjoying some independence in terms of space. The three words involved: *Igwe* is a noun which means number or population, usually a huge number or population. *Bu* is a verb, which means *is*. *Ike* is another verb, which means *strength* or *power*. Thus, put together, it means 'number is strength' or 'number is power', that is, when human beings come together in solidarity and complementarity, they are powerful or can constitute an insurmountable force or strength, and at this level, no task is beyond their collective capability. Igwebuike is, therefore, a philosophy of harmonization, and complementation. It understands the world immanent realities to be related to one another in the most natural, mutual, harmonious and compatible ways possible.

Igwebuike provides an ontological horizon that presents being as that which possesses a relational character of mutual relations. As an ideology, Kanu (2016a&b) opines that *Igwebuike* rests on the African principles of solidarity and complementarity. It argues that 'to be' is to live in solidarity and complementarity, and to live outside the parameters of solidarity and complementarity is to suffer alienation. 'To be' is 'to be with the other', in a community

Disciplines of African Philosophy

of beings. It is anchored on the African worldview, which, according to Iroegbu (1995) is characterized by a common origin, common world-view, common language, shared culture, shared race, colour and habits, common historical experience and a common destiny. Mbiti (1970) classically proverbializes the community determining role of the individual when he writes, "I am because we are and since we are, therefore I am" (p. 108).

The African worldview, therefore, is ruled by the spirit of complementarity which seeks the conglomeration, the unification, the summation of fragmented thoughts, opinions and other individualized and fragmented thoughts and ideas. It believes essentially that the whole is greater than the corresponding parts. It is also a view that maintains that by the coming together of the individual or parts, a viable and sustainable whole will emerge, and by this, the parts will get to the brim purpose of their existence.

The complementary character of reality from the Igbo philosophy of Igwebuike can be compared to Plato's political/ethical theory, according to which, for there to be justice in the state, the three parts that makes up the state, that is, the rulers (the philosophers) the guardians (the soldiers) and the artisans (the labourers) should often work together in one accord with each person doing his or her work efficiently to ensure a peaceful co-existence in the state. According to Plato, if any part refuses to do what he/she is ought to do, there is bound to be a problem in the society. (1987:205). Real potentials of individuals and society is actualized in complementarity than as individuals. "Complementarism is

a philosophy that seeks to consider things in the significance of their singularity and not in the exclusiveness of their otherness in view of the joy that gives completion to all missing links of reality" (Asouzu 2004, 39).

Igwebuike as the Ontological Foundation of an African Logic

Ozumba (2004) observed that every society has its own stock of epistemological thoughts, methods and world views. This assertion is fundamental to epistemology as the quest for knowledge is part of human nature; and thus, it is the prerogative of every culture or tradition. Like every other people, the African has his own method or means of acquiring knowledge. Following from the construct of the African ontology which is complementary, African logic in general is complementary and integral in character, accepting the co-existence of opposing realities as complementary.

African logic is dialectical in character. And by dialectics, it is meant a method of philosophical argument that involves some sort of contradictory process between opposing sides. Its most classic version in ancient Greece is found in Plato. He presented his philosophical argument as a back-and-forth dialogue or debate, generally between the character of Socrates, on one side, and some person or group of people to whom Socrates was talking (his interlocutors), on the other. In the course of the dialogues, Socrates' interlocutors propose definitions of philosophical concepts or express views that Socrates challenges or opposes. The back-and-forth debate between opposing sides produces a kind of linear progression

or evolution in philosophical views or positions: as the dialogues go along, Socrates' interlocutors change or refine their views in response to Socrates' challenges and come to adopt more sophisticated views. The back-and-forth dialectic between Socrates and his interlocutors thus becomes Plato's way of arguing against the earlier, less sophisticated views or positions and for the more sophisticated ones later.

A more refined dialectics is the Hegelian dialectics of thesis, antithesis and synthesis (Etim 2015). Hegel's dialectics refers to the particular dialectical method of argument which, like other "dialectical" methods, relies on a contradictory process between opposing sides. Whereas Plato's "opposing sides" were people (Socrates and his interlocutors), however, what the "opposing sides" are in Hegel's work depends on the subject matter he discusses. In his work on logic, for instance, the "opposing sides" are different definitions of logical concepts that are opposed to one another. In the *Phenomenology of Spirit*, which presents Hegel's epistemology or philosophy of knowledge, the "opposing sides" are different definitions of consciousness and of the object that consciousness is aware of or claims to know. As in Plato's dialogues, a contradictory process between "opposing sides" in Hegel's dialectics leads to a linear evolution or development from less sophisticated definitions or views to more sophisticated ones later. The dialectical process thus constitutes Hegel's method for arguing against the earlier, less sophisticated definitions or views and for the more sophisticated ones later. Hegel regarded this dialectical method or "speculative mode of cognition" as the hallmark of his philosophy.

In African logic, one notices the reliance on the contradictory process of opposing sides. For instance, day is vivified and complemented by night and good by evil. The adage that *"Abasi obot mbat, abot udara ikpat."* Meaning "the God who creates mud made available something to wash off the mud", explains this fact of the complementarity of contradictory realities. The two realities – "mud" and "water" – are mutually opposed but are two sides of the same coin. Anyanwu (1981) describes this contradictory dialectics as the "inner curve of reciprocity" (p. 87) that makes African epistemology to avoid the dualism of subjectivism and objectivism. The contradictory dialectics is not negative but affirms the functionality of differences as essential and incomplete dimensions of the whole.

Conclusion

Contrary to the perspective of Lucien Lévy-Bruhl, a French philosopher, sociologist, and anthropologist who is famous for his study of primitive mentality and his calling for the scientific study of the categories of thought in different societies, who argued that there are two basic mindsets of humankind, 'primitive', or 'pre-logical', and 'civilized', and tried to show that the mechanisms of thinking of these two types of mind were different. Lévy-Bruhl considered that "mystical thinking" was the essence of the primitive mind- the African, whereas rational thinking, based on logic and inference, were the hallmarks of the civilized mind. Also, contrary to Horton's view that Africans, instead employing intuition and ideas, have a rich proliferation of a sort of thinking called magical.

These notwithstanding, within the African epistemological hemisphere, this piece has argued that Igwebuike is the logic of African philosophy, which defines the African presentation of ideas in such a way that they would be reasonable to the African. It has existed informally in African traditional philosophy, and has emerged in a more sophisticated style in contemporary African philosophy through the writings of professional African philosophers. Its distinctiveness is anchored on the belief that human cognition takes place in definite historical and particular socio-cultural contexts. Thus, African logic helps in the presentation of African ideas in such a way that error is avoided, expression is clear, /the reasoning is sound and correct, it informs the prediction of events and sound decision-making, etc.

References

Aja, E., *Logic and Clear Thought: An Invitation to good reasoning* 2nd ed., (Enugu: University of Nigeria Press, 2008).

Anyanwu, K. C. "Pre-suppositions of African Socialism", The Nigerian Journal of Philosophy. 1.2. 1981.

Asouzu, I. (2011). Ibuanyidanda and the philosophy of essence. Calabar: University Press.

Bello, A. *Introduction to Logic* (Ibadan: University Press, 2000).

Copi, I. M, *Introduction to Symbolic Logic* (New York: Macmillan, 1982).

Ejikemeuwa, N. (2015). The nature and function of logic in African epistemology. *Igwebuike: An African Journal of Arts and Humanities*. 1. 1. 63-70.

Francis Etim (2016). "Ibibio Epitsemology". In Kanu, I. A. (Ed.). Published by *Igwebuikepedia: Internet Encyclopedia of African Philosophy* published by the Augustinian Institute of Philosophy, Makurdi. http://igwebuikepedia.info/shared.asp.Online.

Geisler, N. L. and Feinberg, P. D. (1980). Introduction to philosophy: A Christian perspective. USA: Baker.

Horton Robin, "Traditional, thought, and the emerging African philosophy department: A comment on the current debate". *Second Order: A Journal of Africa Philosophy. 3. 1.* 65. 1977.

Iroegbu, P. (1995). *Metaphysics: The Kpim of Philosophy.* Owerri: International Universities Press.

Jasper, K. (1953). Einfuhrung in die philosophie. Zurich.

Kanu, A. I. (2016a). Igwebuike as a trend in African philosophy. *IGWEBUIKE: An African Journal of Arts and Humanities. 2. 1.* 97-101.

Kanu, A. I. (2016b). Igwebuike as an Igbo-African hermeneutic of globalization. *IGWEBUIKE: An African Journal of Arts and Humanities. 2. 1.* 1-7.

Maziarz, E. A. (1987). *'Philosophy',* in The New Catholic Encyclopedia Vol II. London: Chapman.

Mbiti, J. (1970). *African religions and philosophy.* Nairobi: East African Educational Publishers.

Momoh, C. S. (ed.), *The Substance of African Philosophy* (Auchi: African Philosophy Projects Publications, 1989).

Nyarwath, O. (2010). Traditional logic: An introduction. Nairobi: Consolata Institute of Philosophy.

Ochieng-Odhiambo, F. (2009). A companion to philosophy. Nairobi: Consolata Institute of Philosophy Press.

Ozumba, G. O. *A Concise Introduction to Epistemology* (Calabar: Ebeneger Printing Press, 2001).

Quinton, A. (1995). *The Oxford companion to philosophy.* Oxford: Oxford University Press.

Teichmann, J. and Katherine C. E. (1999). *Philosophy: A beginner's guide.* Blackwell Publishing.

www.ingramcontent.com/pod-product-compliance
Lightning Source LLC
Chambersburg PA
CBHW030925180526
45163CB00002B/462